GOUACHE

FOR ILLUSTRATION

GOUACHE
FOR ILLUSTRATION

ROB HOWARD

WATSON-GUPTILL PUBLICATIONS/NEW YORK

Senior Editor: Candace Raney
Project Editor: Virginia Croft
Designer: Bob Fillie, Graphiti Graphics
Graphic Production: Hector Campbell
Text set in Century Old style

First published in 1993 in the United States by Watson-Guptill Publications,
a division of BPI Communications, Inc.,
1515 Broadway, New York, N.Y., 10036

Library of Congress Cataloging-in-Publication Data
Howard, Rob.
 Gouache for illustration/Rob Howard.
 p. cm.
 Includes biographical references and index.
 ISBN 0-8230-2165-3
 1. Gouache painting—Technique. I. Title.
 ND2465.H68 1993 93–17812
 751.42'2—dc20 CIP

Distributed in Europe, the Far East, Southeast and Central Asia, and
South America by RotoVision S.A., 9 Route Suisse, CH-1295 Mies, Switzerland.

Distributed in the United Kingdom by Phaidon Press Ltd., 140 Kensington
Church Street, London W8 4BN, England.

Manufactured in Hong Kong

First printing, 1993

1 2 3 4 5 6 7 8 9 0 / 97 96 95 94 93

ACKNOWLEDGMENTS

Seldom do we do anything truly original. Our accomplishments usually have their roots in the achievements of the past. My debt to past masters is evident throughout the book and the bibliography. My debt also extends to my contemporaries, without whose help this book would have been meager fare.

Of particular help were the manufacturers of artist's materials. They willingly submitted their products to be tested, knowing the results would be reported truthfully and without favor. Not one of them asked for special consideration. Not one of them received it. Although the people I worked with represent large manufacturers, they are individuals, not corporate entities, and should be acknowledged individually.

I am obliged to Lynn Pearl of Winsor & Newton and to W&N's technical whiz Wendell Upchurch for their many considerations. Tim Hopper of HK Holbein spent hours of time and effort securing accurate information for this book. David Ford and Ulrich Hollmann of Schmincke went to extraordinary (and transatlantic) lengths to come to my assistance. The fact that her company no longer produces gouache did not dissuade Donna Chastain of Grumbacher from giving me a great deal of help. Aside from introducing me to a superior product, Ratana Kitvoravat of Turner Colours added artistic insights that proved exceptionally valuable to this project.

Artograph's Lucy Dodd was of inestimable assistance on this and on my previous book. The same must be said about Will Naemura of Medea/ComArt, who shared his vast knowledge of current airbrushing practices and materials. Bill Hoover of Koh-I-Noor and Anthony Moss of Daler-Rowney kindly supplied gouache to be tested and evaluated.

Numerous artists contributed to this book, either directly or indirectly. After twenty-five years of professional association and personal friendship with Jerry Pinkney, it was inevitable that his influence would be felt throughout this book, especially in the area of color. Many of the unusual techniques were developed by Clif Lundberg when we worked together at the Studio For Illustration. Laurie Johnson, Production Manager of Cordella Design, contributed her encyclopedic knowledge of modern scanner technology to the book.

My greatest debt is owed to Dan Tennant and John Ball. Their generosity in creating demonstrations for this book showed, more than anything, a true generosity of spirit. They did the demonstrations for no other reason than to pass on their immense knowledge of this versatile medium.

These are my collaborators and this is *our* book.

CONTENTS

INTRODUCTION

LTHOUGH BREVITY may well be the soul of wit, seldom can it do justice to a subject as complex as art. In my book *The Illustrators Bible,* I gave the reader a broad overview of the new tools and efficient techniques professional artists use to produce high-quality artwork. Such a vast theme could be made brief only through omission and simplification. Faced with a virtual Niagara of information, I had to choose between writing an unduly brief exposition or no exposition at all.

In *The Illustrators Bible,* the chapter devoted to gouache was informative. It was packed with useful tips and techniques, but a single chapter cannot do justice to the remarkable versatility of this ancient medium. Although its popularity has been eclipsed by acrylics, opaque watercolor has remained with us since antiquity, and for good reason. Among its many qualities is permanence. There are still well-preserved opaque watercolors done well before the first of the Egyptian dynasties. While the history of opaque watercolor is intriguing, this is not a book about art history. The purpose of this book is to get you to paint with gouache, and to paint well, so let's get to it.

The book is arranged so that you can follow along, duplicating the demonstrations and developing the special understanding that comes only by doing. You cannot learn to paint with gouache just by reading about it, no more than you can become a proficient skier just by sitting in a chair reading a book. I know most artists dislike the idea of copying another artist's work, but try to think of it as a form of practice. Technique that appears to be effortless results from great effort spent in practice.

Copying has even helped people with limited talent appear more talented than they really were. For instance, in Victorian England well-bred young women were expected to learn, among other skills, to play a musical instrument and to draw and paint. Judging from the many watercolors that have survived, they would make watercolor sketches of points of interest they

encountered while traveling. In a way, this was the Victorian version of taking snapshots. While these sketches cannot be considered the work of true artists, an overwhelming number of them are quite competent. That competence was the result of copying and repetition. Because you are an artist, by using this book as your guide, you'll be able to do much more.

The demonstrations start simply and become more involved as the book progresses. As you follow along, copying and repeating the demonstrations, you'll develop a level of skill you never thought possible. I speak from experience, since I entered the field of art with every intention of becoming a "fine artist"— a painter. Like so many painters, I viewed illustration with undisguised disdain. Upon becoming more familiar with the field, however, I learned that my temperament was more suited to becoming an illustrator—I like to tell stories with my pictures. The greatest benefit was that the range and demands of my assignments forced me to grow and develop skills that otherwise, as a fine artist, I might not have acquired. It is an indisputable fact that, for developing hand-eye coordination, repetition is the mother of all skill. As the cartoonist Doug Marlette once said, "You can't get any worse with practice."

Before we get to the step-by-step demonstrations I'll show you what's so special about gouache and point out which manufacturers make the best paints and why they are the best. You'll learn which tools you absolutely must have and those which, while not absolutely necessary, are nice to have in the studio. I have included a chapter on color that has been designed to dispel the crippling myths surrounding the subject. This is followed by a chapter that presents a number of handy color recipes for various fleshtones and different hair colors, as well as techniques and recipes for various metals and other materials. In learning color strategies, you'll be learning something much more important. You'll be learning the underlying principles that allow you to translate whatever you see into paint.

Make no mistake about it—*you're going to get good at this.*

1 GOUACHE
WHAT IS IT?

OIL PAINTS are oil paints. Pastels are pastels. But gouache . . . well, there's been a lot of confusion about gouache. Over the years the terms *gouache* and *tempera* have come to mean many different things. Gouache has also been confused with poster paints. In this chapter we'll try to unravel the tangle of terms and straighten out their meanings as we compare gouache to other mediums. We'll examine what's packed inside the tube so that you will know what to expect when you buy gouache. You'll learn how gouache behaves, as well as how it misbehaves, and try out some simple tests that you can use to evaluate different brands of paint. The chapter concludes with a mini consumer's guide to the best-quality gouache.

Most artists know that gouache is the opaque cousin of watercolor. Like watercolor, it is pigment in a gum-based solution. Many think of gouache as little more than high-quality poster paints—brilliant, opaque colors that dry to a matte finish. While gouache is ideal for rendering flat areas of color, it is capable of more, much more. Few artists know that it can be made to produce an airbrush-smooth blending of tone and color, easily and without an airbrush. This ability to produce subtle blends accounts for gouache being the medium of choice among many professional illustrators. An hour or two of practice will convince you to use gouache. I guarantee it.

HOW GOUACHE COMPARES TO OTHER MEDIUMS

Most art historians will tell you that the fifteenth-century painter Paolo Pini's oft-quoted line—"Let us leave guazzo to the Flemish, who have lost sight of the true road. We, however will paint in oils"—refers to the tempera (gouache) used by the Flemish masters. After all, *guazzo* sounds like *gouache,* right? Wrong. According to no less an authority than Max Doerner, what Master Pini was referring to was the practice of painstakingly building up underpaintings in shades of gray before glazing with color. The French called that gray underpainting *grisaille* and the fifteenth-century Italians called it *guazzo.* Pini was simply trying to publicize the advanced techniques he and his countrymen were employing. He was waging the Renaissance version of a public relations campaign.

Emulsion-Based Paints

Before the universal acceptance of oil paints, easel painters worked with a variety of opaque watercolors. The most common was egg tempera applied with small hatched strokes. A carefully rendered monochrome underpainting was glazed with transparent color, in much the same way a photograph is tinted. This was the guazzo underpainting technique Pini wrote about. Unlike oil paint, egg tempera dries quickly and allows for painting razor-sharp edges. But if the tempera artist wanted to paint fused edges with soft transitions, the painstaking method of hatching egg tempera worked against his best efforts.

Nowadays any kind of opaque watercolor is called tempera, but that term should be applied only to paints whose vehicle is an emulsion, which excludes gouache. What's an emulsion? The yolk of an egg is a natural emulsion, a cloudy mixture of oily and watery elements held in suspension. As anyone who has tried to wash dried egg yolk off a plate can affirm, emulsions dry to a hard, water-resistant film.

Try this. Mix a little water into an egg yolk, stir in some dry pigment, and *voilà*—you've made egg tempera. It's just that simple. You'll find it handles smoothly and quickly dries to a soft sheen with a jewellike translucency. Once egg tempera sets and dries, subsequent layers and glazes can be applied. If you don't have any dry pigments lying around your studio, you can mix the egg with tube watercolors. Give it a try; all you've got to lose is an egg.

Another emulsion still enjoying a degree of popularity is casein, which is derived from milk. The nursery rhyme about Miss Muffet's curds and whey mentions the main ingredient in casein. The fresh curd from skim milk is ground with a bit of slaked lime (calcium hydroxide) until it turns into a liquid. For centuries it has been used as a strong wood glue that can withstand exposure to the elements. That same glue, when ground with pigment, results in a paint that can withstand the abuse

of centuries. The casein paints manufactured for the artist, however, are a bit different. They are made by mixing skim milk curd with ammonia. Although not as water-resistant as the paint made with slaked lime, the ammonia produces a much smoother-handling paint.

Before the introduction of acrylic paints, casein was a favorite of both illustrators and easel painters. Casein's quick drying still makes it of particular value to illustrators faced with tight deadlines. The velvety matte surface guarantees that the colors will reproduce true and be free from the reflective glare that often plagues illustrations done with oil colors. Also, casein's opacity makes it easy to get effects with one stroke that would require repeated applications with acrylics or oils. Acrylic paints (which used to be known as polymer tempera because they were ground in a polymer emulsion) have largely supplanted casein, even though acrylics have qualities very different from those of casein. Only one company, Shiva, is still manufacturing casein. Fortunately, they always made the best casein and their current product is still excellent.

Natural emulsions dry and harden permanently and, because of their oily constituents, can be used in conjunction with oils. They also adhere to oil grounds. The same cannot be said of acrylics or gum-based paints like watercolor and gouache. Pigments ground in a gum solution simply will not adhere to an oil ground.

The Ingredients in Gouache

Egg tempera is semi-transparent and can be made by simply mixing the yolk of an egg with dried pigment or watercolor.

The gum base in gouache is the stuff you've seen oozing out of trees. Indeed, trees are where most gums come from. Many have romantic names evoking exotic places: gum Arabic, Senegal, Kordofan. Others have names that speak to their source: cherry gum comes from cherry trees. Then there's dextrin, a gum made by roasting starch and treating it with an acid. Dextrin improves handling by overcoming the stickiness inherent in many pigments. Its overuse, however, can make for a coarse paint resembling poster color. Because it is cheap and improves handling, dextrin has become a major ingredient in many of the cheaper brands of gouache.

Other ingredients (described under the rubric of *plasticizers*) are added to gouache. Some of the cheaper brands contain large quantities of sugar syrup. While a little sugar syrup does indeed improve handling characteristics, too much results in tell-tale dark rings surrounding blobs of dried paint on your palette. The major problem you'll run into when using paint made with too much sugar syrup is the tendency for the color to shift value upon drying. In poorly made paints, the color you see when the paint is wet is not what you see when it is dry. This shift is

particularly noticeable when painting with grays, and it's the one of the main frustrations faced by new users. Another plasticizer is glycerin. Too much of it makes for a paint that dries with a sticky surface. As you can see, manufacturing the right qualities into a paint is a delicate balancing act.

Another thing the paint manufacturer must contend with is the varying qualities of different pigments. Aside from being expensive, some pigments, like phthalocyanine blue, have so much tinting strength that a pound of pure pigment would be enough to stain a small town blue—dark blue. Such pigment strength needs to be reduced to manageable levels. Other pigments have poor brushing qualities and require the use of additives to make them handle smoothly. Inert fillers like alumina hydrate, precipitated chalk, and blanc fixe are added to control the tinting strength of powerful pigments and improve the handling qualities of the paint.

Most inert fillers are white or nearly white pigments that, when ground in oil, become almost clear. But when these same fillers are mixed with water, they remain white and opaque. You can observe something similar in the kitchen. If you mix flour with cooking oil, it becomes almost transparent, but if you mix it with water, it remains white. That phenomenon accounts for the opacity of gouache. Indeed, the gum mixture used in manufacturing transparent watercolor is identical to that used for gouache. The difference is in the type and amount of inert fillers used in gouache. Also, watercolors are ground very fine and under great pressure. Because they are not meant to be used straight from the tube, brushability is not a major concern; thus watercolors can be ground to a thicker consistency than gouache.

Gouache vs. Watercolor

All of this brings up the differences between watercolor and gouache. Watercolor looks best when it is not much more than a transparent stain on the surface of the paper. The paper must be absorbent enough to catch and hold the finely ground particles of pigment. Watercolor relies on the whiteness of the support to impart brilliance. Gouache, on the other hand, is not used as a stain—it's a paint. Gouache lies on the surface in a measurable thickness. The support need not be absorbent because gouache contains enough gum to adhere effectively to any but the slickest surface. Unlike watercolor, gouache will show up when painted onto a dark-colored support. Not only will it show up, but well-made gouache will dry rich and vivid on a dark support.

Gouache is not the only paint that is intense and opaque when painted onto a dark support; there's also poster paint. For most of us, poster paint was our introduction to the world of art. But put

Unlike watercolor, gouache shows well when painted onto a dark-colored support. Not only does it show well, but high-quality gouache dries rich and vivid when painted onto a dark support.

Poster paints and cheap gouache are not suitable for professional use because they are made with a starch binder. Starch cracks and flakes when it dries.

aside your warm memories of this product because poster paint is not meant to be used for professional artwork. It is meant to be used by children and must be safe enough for a child to gulp down a jar of it with no ill effects. The binder is starch, which is safe to swallow. Unfortunately, when starch dries, it cracks and flakes off the support. Poster paint is really not much more than brightly colored library paste. Perhaps the worst thing about poster paint is the manufacturer's insistence on calling the stuff tempera. As we know, *tempera* refers to high-quality paints made with emulsions, not starch. Liquitex makes a poster color with fluorescent pigments which they rightly call Fluorescent Poster Color. But they call their nonfluorescent paint Tempera Poster Color. The label on the Rich Art jar says it's "For Tempra" (*sic*). No wonder there's such a confusion of terms.

Adhesive-Based Paints

Thus far we've discussed paints made with emulsions like milk and eggs, paints made with vegetable gums, and paints made with starch. There's another category of natural binders used in the manufacture of paint—glue. Lots of adhesives are called glue, but that term is properly applied to adhesives made from animal products—hooves, hides, and such. The glues most familiar to artists are rabbitskin glue and gelatin. Anyone who has worked with them knows that if they are to remain liquid they must be kept warm. Upon cooling they harden to a rubbery gel. When pigment is mixed with the warm glue, it produces a paint known as distemper. The best-known form of distemper is the gesso we've all made with white pigment and rabbitskin glue. Distemper is still used in the decorating trades, but aside from its use in making gelatin size or gesso, it is of only academic interest to most artists.

All of the paints described so far would have been familiar to Paolo Pini and his contemporaries. In the 1950s a revolution took place in paint manufacture when water-soluble polymer emulsions were used as a binder for artist's paint. Then they were called polymer temperas. Today we know them as acrylics. It is not the purpose of this book to discuss acrylics, which have qualities very different from gouache. Out of polymer technology, however, arose the first real breakthrough in gouache manufacture in the last six hundred years—the acryl resin vehicle—which is discussed under Holbein Acryla Gouache on page 21.

HOW GOUACHE BEHAVES—AND MISBEHAVES

One of my favorite cartoons shows a wizard who has just conjured up a demon, a very puny demon, who informs the wizard, "If you use inferior materials, you get inferior demons." The same holds true for artist's materials. If you use inferior paint, you'll get inferior paintings. Therein lies the problem with "student-grade" materials. A practiced professional might have the skill to overcome the poor handling qualities of cheaply made paint, but it's a cruel deception to expect a fledgling artist to be able to conquer the difficulties built into substandard materials. I believe one of the reasons so few art students ever become professionals can be laid to early training using student-grade paints. So if you're just starting out and are unsure whether you'll even like working with gouache, don't buy a full set of student grade paints. Instead, spend the same money on a limited palette of top-quality gouache.

Tests for Different Qualities

I have developed very definite likes and dislikes for various brands of gouache. But do not blindly follow my recommendations; test a few brands of paint for yourself. I've devised some

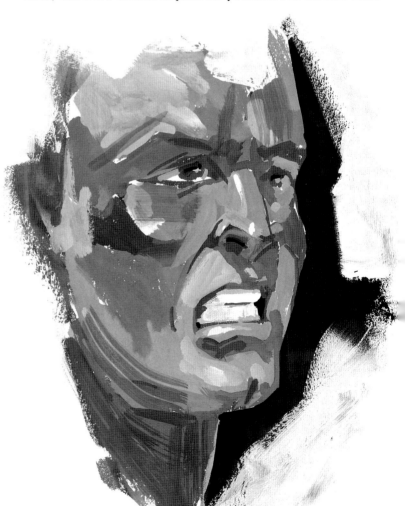

Painting swatches will not give you much information about a paint's handling qualities, but rendering a form will tell you volumes. When doing a quick study like this, use everything from thin washes to full-bodied layers of paint.

To compare different brands for opacity, paint swatches on a page from a magazine with type on it. Glossy-coated paper works best because it is less absorbent and forces the paint to sit on the surface. The stark black type will strike through all but the most opaque colors.

tests to help you compare different brands of gouache. The operative word is *compare,* which means you must have similar products from different manufacturers. That is, compare one brand of cadmium red light with other brands of cadmium red light. Do not compare cadmium red light with barium red or flame red.

First I use a simple test to compare opacity. I paint swatches of different brands of gouache on a page that has type printed on it. Glossy-coated paper works best because it's less absorbent and will allow the paint to sit on the surface. Because the type is printed in stark black on white paper, it will strike through all but the most opaque of colors. Throughout these tests, it is very important to thin the paint equally and apply only one coat. Totally opaque paint is said to have good "hold out."

Next I paint swatches on white, gray, and black supports to compare the brilliancy of different brands. This test should be done with every color you want to use because there are wide variations between brands. After these tests, you may end up with a palette that includes an ultramarine from Schmincke, a cerulean from Holbein, and a myosotis blue from Winsor & Newton. It's all right to have a palette composed of several manufacturers' paints because they're all compatible.

For my final test I paint a quick study, usually of a human head and usually in monochrome. Painting swatches won't test a paint's handling qualities, but rendering a form will tell you volumes about how a paint handles. In this quick study, use everything from thin washes to full-bodied layers of paint. One word of caution: don't try to apply gouache in thick impasto layers. Gouache is meant to give maximum opacity with fairly thin coats. Thick layers of gouache risk cracking and flaking when dry. If you want impasto effects, use oils, alkyds, or acrylics.

By painting swatches on white, gray, and black supports, you can compare the brilliancy of the same colors from different manufacturers.

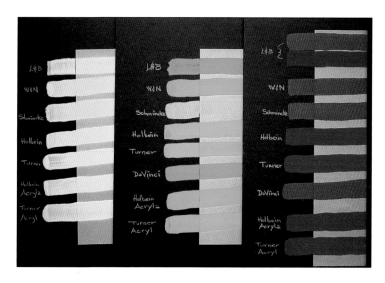

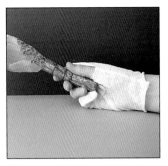

The natural oils in your hands can make slick spots on the surface of gouache, causing the color to change. You can prevent this by wearing thin cotton gloves. To feel the brush, cut off all the fingers except the little one, which will rest against the surface.

Problems with the Medium

For the illustrator, the ability to reproduce flawlessly is one of gouache's biggest attractions, but the medium is not without its drawbacks. The flat, matte surface can easily be marred. A careless scrape with a piece of metal like a ring or watch will leave a permanent shiny streak. Rubbing the surface with an eraser will polish the surface, changing the color and making it shiny. The natural oils from your hand can make slick spots, mottling the surface and causing the color to change. You can avoid this last problem by wearing cotton gloves, the kind made by Kodak for workers in photo labs. In order to be able to feel the brush, cut off all the fingers except the little finger, which usually rests on the support. Lightweight and comfortable, these gloves are a must if you want to produce an illustration bearing the mark of a true professional—a flawless surface.

One of the first things you'll notice about gouache, when laying in a large area of color, is its tendency to streak. Gouache dries so quickly that overlapping strokes build up and are impossible to hide. Impossible unless you mix a small amount of ox gall into the paint. Ox gall is a purified bile solution that has been used as a wetting agent since the time of the Romans. You should add a dozen drops of ox gall to a cupful of distilled water and use this mixture to dilute your paint. No matter how small the area to be painted, I always put ox gall in my mixing water (distilled water, not tap water). Winsor & Newton manufactures ox gall, so it should be readily available. If you haven't got any ox gall in your painting kit, you can add two or three drops of liquid detergent or Calgon water softener to your water, but you should always be sure to test them before using on an important piece.

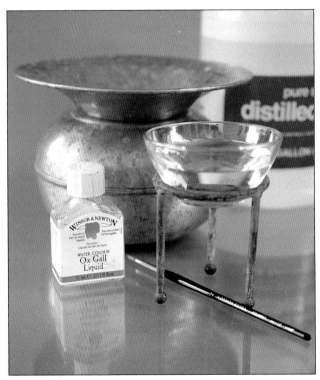

Ox gall is a purified bile solution that acts as a wetting agent to keep gouache from drying too quickly. Add about a dozen drops to a cup of distilled water and use this solution to dilute your paint.

I don't want you to think that the surface of a gouache illustration is so delicate that you can't even breathe near it. If you handle it properly, you should have no difficulty. Proper handling extends to your choice of drafting brush. For cleaning off the surface of a gouache illustration, the standard engineer's drafting brush might prove too coarse. Instead, try using a goat-hair drafting brush or my personal favorite, a sterilized duck's wing from HK Holbein.

BRANDS OF GOUACHE AND THEIR CHARACTERISTICS

For years many manufacturers treated gouache as a back-of-the-shelf product. Fortunately, in recent years some of those same manufacturers have put great effort into developing and improving gouache. Today's first-tier gouache surpasses the paint of only a few years ago. The following information will help you select the best paint for your needs.

You'll find that price is an inaccurate gauge of quality. Some of the most expensive gouache is as poorly made as the cheapest brands, and one of the least expensive brands is a surprising value. Only tube gouache is reviewed here. Although cakes (or discs) are handy for the occasional user, they are of little value to the working illustrator.

The best-quality paints are all distinguished by the purity and depth of their color, a uniform consistency, excellent covering power with minimal tonal changes upon drying, and superb handling qualities. Some of the inferior paints are badly ground and gritty. They drag on the brush, have poor covering power, are chalky, and leave mottled shiny spots of the vehicle when dry (or the vehicle itself separates from the solids in the tube). So-called student-grade paints are the worst offenders, but with one high-priced brand, the vehicle (which contains no gum) forms unsightly dark rings around each brushstroke upon drying—ghastly stuff.

All of the gouache paints rated with stars on the following pages are top-quality products. They have slightly different characteristics, making some better than others for your particular working methods. I urge you to make your own tests from among these recommended products.

Winsor & Newton Designers Gouache

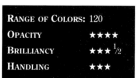

RANGE OF COLORS: 120	
OPACITY	★★★★
BRILLIANCY	★★★$\frac{1}{2}$
HANDLING	★★★

With its range of more than 120 colors, this English company is the best-known manufacturer of gouache. Although the old Winsor & Newton metal tubes and caps were charming to look at, the company's improved packaging has aided in keeping the paint moist in the tube (some of the less scrupulous manufacturers solve the problem of moistness by simply adding more water to the paint). The range of colors in Winsor & Newton Designers Gouache is astonishing. It includes more variations of red than the total colors in some manufacturers' entire line.

Winsor & Newton provides the most complete technical information of all the manufacturers. This is especially important to the fine artist who wishes to paint only with permanent colors. For the illustrator, to whom permanence is subordinate to effect, many of the more fugitive colors (especially in the purple and red-purple range) are useful.

Winsor & Newton Designers Gouache: Offering a range of more than 120 colors that are available in almost every art supply store, this English company is the best-known manufacturer of premium-quality gouache.

Winsor & Newton Designers Gouache handles smoothly and predictably, although there are the normal variations in flow and consistency from color to color. Nevertheless, all of the colors dilute easily with water. Among the first-tier brands, Winsor & Newton Designers Gouache is one of the most opaque, without being chalky. An especially useful area of the color range is the grays. There are five values of warm gray, five values of cool gray, and another five values of neutral gray. Highly recommended.

Holbein Gouache

RANGE OF COLORS: 63	
OPACITY	★★★ $^{1}/_{2}$
BRILLIANCY	★★★★
HANDLING	★★★★

Although lacking the huge color range of Winsor & Newton Designers Gouache, Holbein Gouache has more than enough colors for the professional illustrator. By virtually eliminating the purples and red-purples from its line, Holbein has produced a range of 63 colors geared to permanence. Many useful purples can be mixed from the reds and blues. Holbein offers three neutral grays from which you can easily mix the intermediate values.

If one thing can be said to distinguish all the paint manufactured by this Japanese company—whether gouache, oil, or watercolor—it is uniform consistency. Holbein adjusts the grinding times of each pigment to produce optimum consistency and brilliance. The Holbein Gouache color range is not as opaque as Winsor & Newton Designers Gouache, but the colors have great depth and sparkle. Because of the attention given to uniform consistency, Holbein Gouache has unparalleled handling qualities.

Holbein Gouache is not as readily available as Winsor & Newton Designers Gouache, but its special quality justifies a search. Uniformly excellent.

Holbein Gouache: Although not as opaque as Winsor & Newton Designers Gouache, the 63 colors of Holbein Gouache have great depth and sparkle. Because of the emphasis the company places on uniform consistency, this gouache has unparalleled handling qualities.

Holbein Acryla Gouache

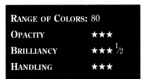

RANGE OF COLORS: 80	
OPACITY	★★★
BRILLIANCY	★★★ $\frac{1}{2}$
HANDLING	★★★

There is nothing else like Holbein Acryla Gouache. It is unique in using a crystal-clear acryl resin vehicle rather than a gum base. It is not at all like acrylic paint. Holbein Acryla Gouache dries to an absolutely dead matte finish—a richer matte than that of most gum-based gouache. For the first 10 to 15 minutes, it is as workable as traditional gouache. After that, it becomes less soluble. Although not as water-resistant as acrylic paints, it is less soluble than traditional gouache. Because many gouache colors are formulated with soluble dyes, they can strike through any colors painted on top of them. The threat of colors striking through subsequent coats of paint is greatly reduced with Holbein Acryla Gouache.

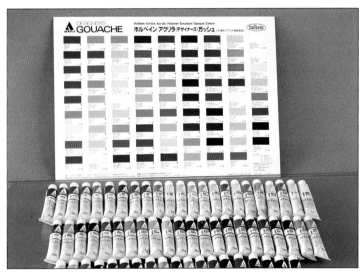

Holbein Acryla Gouache: Ground in a clear acryl resin, Acryla Gouache is flexible and will not crack when wrapped around the drum of a scanner. Unlike an emulsion, the acryl resin does not change color upon drying. Unlike traditional gum-based gouache, Holbein Acryla Gouache does not shift color as it dries.

The full color range for Holbein Acryla Gouache comprises 80 colors. There is a wide selection of brilliant purples and red-purples but a very limited number of reds. Because there are no cadmium colors, Holbein Acryla Gouache is lower in price than traditional Holbein Gouache.

Its acryl resin base makes Holbein Acryla Gouache flexible; it will not crack when artwork is wrapped around a scanner drum for color separation. Because it is made with a clear acryl resin rather than a cloudy acrylic emulsion, Holbein Acryla Gouache does not change color upon drying. Also, unlike traditional gum-based gouache, it does not shift color as it dries. What you see when it is wet is what you get when it is dry.

Holbein Acryla Gouache is compatible with gum-based gouache, and airbrushed passages can be done with traditional gouache on top of Acryla Gouache. I urge you to try this new form of gouache.

Schmincke HKS Designers Gouache

RANGE OF COLORS: 84	
OPACITY	★★★
BRILLIANCY	★★★★
HANDLING	★★★ $\frac{1}{2}$

Nowhere is the German dedication to quality more apparent than in the manufacture of Schmincke gouache. Schmincke makes two distinct types of gouache: Schmincke HKS Designers Gouache and Schmincke Artists Gouache. Schmincke HKS Designers Gouache is a gum-based paint in which both pigments and soluble dyes are combined for maximum brilliancy. It is used in Germany as part of a color-mixing system that includes pre-mixed printer's inks. Color for color it is the most brilliant of any of the many brands tested for this book—as brilliant as Holbein Gouache but slightly less opaque—and the handling qualities are superb. In addition to a range of 84 colors, Schmincke HKS Designers Gouache offers 6 different types of black, 7 different types of white, and numerous grays, including a special "mixing gray" that neutralizes colors without making them dead.

Schmincke HKS Designers Gouache: A gum-based paint using both pigments and soluble dyes for maximum brilliancy, Schmincke HKS Designers Gouache is almost as opaque as Winsor & Newton Designers Gouache and perhaps more brilliant than Holbein Gouache. Its handling qualities are superb.

Schmincke Artists Gouache

RANGE OF COLORS: 60	
OPACITY	★★★
BRILLIANCY	★★★★
HANDLING	★★★ $\frac{1}{2}$

Schmincke also manufactures a wholly pigmented gouache. Unlike Schmincke HKS Designers Gouache, it is not manufactured with soluble dyes. For the artist concerned with permanence, Schmincke Artists Gouache is the brand of choice because it is as brilliant as most designers colors. Of course, some colors are available only as soluble dyes. I'd recommend Schmincke Artists Gouache to the illustrator who, even though not overly concerned with permanence, wants to avoid the risk of underlying colors striking through the top layers of paint. Schmincke Artists Gouache is expensive.

Schmincke Artists Gouache: Only fully pigmented colors are included in this line of gouache. As brilliant as most designers colors, they are made for the fine artist who is concerned with permanence. They are also favored by illustrators who want to avoid the risk of underlying colors striking through the top layers of paint.

Unfortunately, Schmincke HKS Designers Gouache and Schmincke Artists Gouache are hard to find in this country. New York Central Supply is one of the few companies stocking both products.

Da Vinci Gouache

RANGE OF COLORS: 84	
OPACITY	★★★
BRILLIANCY	★★ $^1/_2$
HANDLING	★★ $^1/_2$

This American company prices its full-sized studio tubes of gouache below most other manufacturers' 15-ml tubes. Although it is lower in price, Da Vinci Gouache is made with pigments having lightfastness ratings of I (excellent) or II (very good), ground in a natural gum-based vehicle to a very soft and smooth consistency. The colors are brilliant and fairly opaque yet not chalky.

The color range of Da Vinci Gouache includes only 28 colors, but they're well-chosen colors. This product is not widely available but can be purchased by mail order. Da Vinci Gouache offers an excellent value for little money.

Da Vinci Gouache: The 28 colors in this line of gouache are smooth, brilliant, and opaque. Packed in large studio tubes, they are also an excellent value for little money.

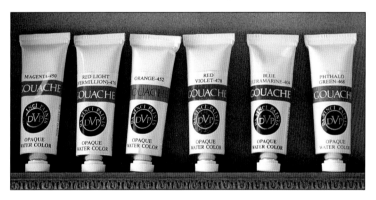

Turner Design Gouache

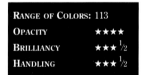

RANGE OF COLORS: 113	
OPACITY	★★★★
BRILLIANCY	★★★ $^1/_2$
HANDLING	★★★ $^1/_2$

Osaka, Japan, is home to both Holbein and Turner Colour Works, and cross-pollination and friendly competition are evident in the products of both manufacturers. I was well into writing this book when Turner Design Gouache came to my attention. The people at Turner's New York office informed me that Turner Design Gouache is the best gouache in the world—bar none. It was with more than a little skepticism that I tried it, but to a great extent it lives up to the boast. It is superb.

As with most artist's materials, preference is a result of personal taste. Turner Design Gouache has a range of 113 colors and is by far the most opaque of all the brands recommended. Its brilliancy of color ranks at the top, and its handling qualities allow flawlessly smooth blending of tonal transitions.

I especially recommend Turner Design Gouache to artists whose work relies on opaque and brilliant color. For that purpose it is unsurpassed. Although it has superb ability to blend transitional tones, upon drying it shifts tone a bit more than any of the other brands tested. Once you learn how to judge the tonal shifts, Turner Design Gouache will indeed live up to its claim.

Turner Design Gouache (on the right): Offered in a range of 113 colors, this gouache is by far the most opaque of all the brands recommended. The brilliancy of color is also superior, and the handling qualities allow flawlessly smooth blending.

Turner Acryl Gouache (on the left): Because this gouache is made with an acrylic emulsion, which is a strong binder, it cannot be blended as easily as Holbein Acryla Gouache. That film strength, however, makes it an excellent choice for use as an underpainting because it is undisturbed by overpainting.

Turner Acryl Gouache

RANGE OF COLORS: 75	
OPACITY	★★
BRILLIANCY	★★★
HANDLING	★★

Not to be outdone by their neighbors at Holbein, the chemists at Turner Colour Works created Turner Acryl Gouache. Unlike Holbein Acryla Gouache, which is made with a clear acryl resin vehicle, Turner Acryl Gouache is made with an acrylic emulsion. There are several differences: the clear acryl resin in the Holbein product is softer and less water-resistant than the acrylic emulsion in the Turner product. Also, Holbein Acryla Gouache does not shift color or tone upon drying, whereas Turner Acryl Gouache does. And it is the least opaque of all the paints recommended.

Because of its stronger binder, Turner Acryl Gouache cannot be blended with the ease of Holbein Acryla Gouache. That film strength, however, allows the artist to overpaint with little fear of disturbing the underlying paint. Turner Acryl Gouache dries in 5 to 15 minutes to a dead matte finish.

Other Brands Tested

Manufactured by LeFranc & Bourgeois, Linel Designers Gouache resembles other LeFranc & Bourgeois paints in having a large number of proprietary colors. This French manufacturer has a very different idea of what constitutes good gouache. Linel colors vary from opaque to semi-transparent. To make the transparent colors opaque, you must add white, which, of course, raises the value of the color. Also, in order for Linel Designers

Gouache to be opaque, it cannot be thinned to the usual workable consistency—it must be applied thickly. It's not that Linel is poorly made—it's oddly made. Because of its odd characteristics, it is not suitable for many of the techniques in this book.

The English manufacturer Daler-Rowney produces Rowney Designers' Gouache, which bears a striking resemblance to poster colors. Rowney colors are chalky and lack depth and sparkle. When diluted, they show the least pigment of all the brands tested. These paints are definitely not capable of producing the results shown in this book.

A Word About Permanence

Although this book includes some consideration of gouache as a medium for the fine artist, its main thrust is to provide information to the illustrator. Illustrators are more concerned with achieving certain effects than with producing pictures that will remain unchanged for centuries. It's a fact that some pigments are less permanent than others. Because gouache is manufactured for the decorative artist and illustrator, a few of the more attractive and useful pigments are downright fugitive. Some fugitive pigments have unusual names like Bengal rose and myosotis blue. These are left over from the 1930s when Winsor & Newton made colors especially for English wool carpet designers; hence the name *Designers* Colours on W&N's gouache. Sometimes unusual color names point to less-than-permanent pigments, but names alone are not a reliable indicator of permanence. The better manufacturers publish charts rating the relative permanence of each color in their line. Winsor & Newton publishes the most informative and complete information of any manufacturer. These charts are the most reliable guide to permanence.

Over the years a number of authors have written authoritative books urging students to select only permanent pigments and to apply them in carefully built-up layers, not slather the paint on, as van Gogh did. Although artistic merit cannot be judged only in terms of money, there doesn't seem to be much of a clamor in the world's galleries for the technically perfect paintings of those writers, whereas van Gogh's technically imperfect paintings command tens of millions of dollars. To me the message is clear—the practice of art is more concerned with conveying one's original thoughts than with sticking to rule books written by a few paint chemists and art restorers. Certainly you should try to paint with permanent colors whenever possible, but tailor your technique to your personal vision, not vice versa. If your work is worth preserving, it will be preserved.

A few of the more attractive and useful pigments are fugitive and have unusual names like Bengal rose and myosotis blue. Such colors from Winsor & Newton were named in the 1930s when they were created especially for English wool carpet designers; hence the term Designers *on the label.*

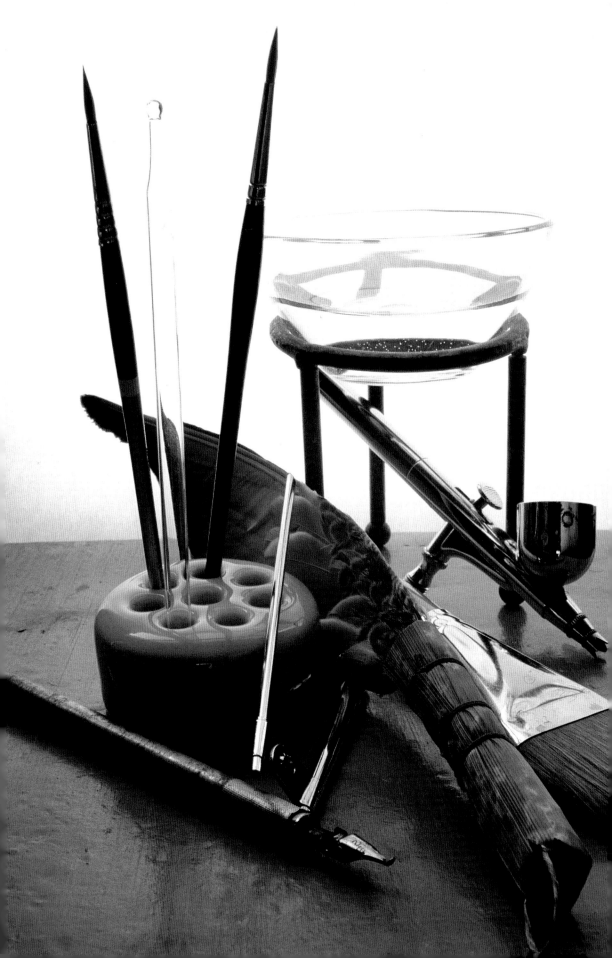

2 TOOLS
OF THE TRADE

Most artists treat a day at the art supply store as though it were Christmas. I know of no other profession so in love with the tools of its trade. I myself look forward to seeing the latest in colors, papers, labor-saving tools, and gizmos. I have a studio full of gizmos—those things that looked promising but now serve as nothing more than monuments to my credulity. I suppose we've all got a collection of similar tools that promised much more than they delivered. But this chapter is not about useless gadgets. In this chapter we will cover the tools you need for gouache painting, as well as some accessories that can save time or work. Along with the tools, we will also discuss the best supports for gouache painting.

What works for one illustrator may not meet the needs or preferences of another. Selecting brushes, for example, is a highly individual matter. Because there are so many watercolor brushes offered by so many manufacturers, I have devised a number of tests that will enable you to choose the best quality. In this chapter you will also learn about the advantages and disadvantages of different supports and discover how you can improve the handling qualities of gouache. It is important to remember, however, that as much as we may be enamored of the materials and tools of our trade, they are only tools. They're only as good as our skill and technique make them.

BASIC HARDWARE

S ince you are not a beginner, I will assume you have such basics as a drawing table, a good desk lamp, and a tabouret or other small cabinet for your tools. You probably have at least one T-square, numerous triangles, and circle and ellipse templates. What I want to include here are some of the special tools that I have found particularly useful when working with gouache.

Palette

What do you use for a palette? If you've ever used an extruded white plastic palette for mixing acrylics, you've doubtless had to struggle with removing dried paint from it. That's not the case with gouache. Dried gouache cleans up easily from plastic palettes and cups. Ceramic cups are even better. One of my favorite palettes is a 20" x 30" (50 x 75 cm) sheet of 1/4" (6 mm) glass. For very little money, you can have the glazier round the sharp edges.

Because color mixtures are easier to judge when placed on a neutral gray, back the glass with a sheet of medium gray paper or card—approximately matching a sheet of Pantone 429. A gray scale card should be included in one corner. The gray scale will help you to accurately judge the values of your color mixtures—misjudged values being the prime source of most painters' difficulties. In the next chapter I'll show you how to make your own gray scale card.

A 20" x 30" (50 x 75 cm) sheet of 1/4" (6 mm) glass makes an ideal palette. Back the palette with a medium gray paper or card that approximates Pantone 429. To aid in matching values, a gray scale card should be included in one corner.

Table Easel

Have you ever used a table easel? It has several advantages for gouache as well as other quick-drying or drippy paints. Because the illustration is held vertically, dust won't settle on it and get painted into the surface. Also, a table easel minimizes accidental drips of paint. It takes a bit of getting used to, but when you use a table easel in combination with white gloves and a duck's wing duster, it is the surest guarantee of a flawless surface.

Magnifying Lens

If you've ever marveled at some illustrator's sureness of strokes and precision of details, here's a sure-fire and easy way you can achieve similar results—use a magnifying lens. Learning to work under a magnifying lens takes 15 minutes of practice, but once you're used to it you'll never be without one. The one I prefer is mounted on a flexible gooseneck shaft to hold the lens 6" to 8" (15 to 20 cm) above the surface. You'll be amazed at the precision with which your hands can guide a brush when viewed under a lens.

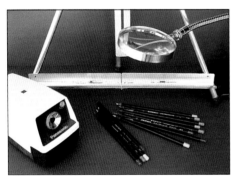

A table easel is especially useful when spraying gouache through an airbrush because it eliminates runs. A magnifying lens can be used for viewing when you want to improve the quality of edges and details. Colored pencils are an excellent means for adding detail and special effects to a gouache illustration. Keep them sharp with an electric pencil sharpener, which sharpens only the point.

Pencil Sharpener

For the illustrator, colored pencils sharpened to a fine point are almost indispensable—you can use them for just adding details or for extensive rendering. Because the surface of a gouache painting has a texture like superfine sandpaper, the point of the pencil is easily worn down and needs frequent sharpening. Manual sharpeners grind away too much, whereas electric pencil sharpeners like the Panasonic with its Auto-Stop feature won't oversharpen those expensive pencils. Most importantly, because electric sharpeners are so simple to use, you'll be more likely to draw with a sharp point.

Opaque Projectors

Virtually every illustrator uses photographs. Visual information that once was gathered with quick sketches and notations is now collected with a camera. At times you may be able to use existing photos; at other times you'll want to take your own photos. While it's easy to slavishly use photography to the detriment of your painting, the camera can be a great help in your work.

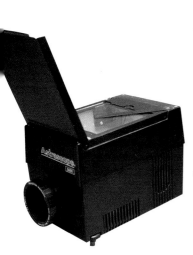

The Astrascope 5000 opaque projector has a powerful halogen lamp and will handle photos up to 6" x 6" (15 x 15 cm). Horizontal projectors can only enlarge an image. They cannot make reductions.

Probably no other piece of studio equipment is surrounded by so much myth and misinformation as is the opaque projector. Some purists (usually artists whose work doesn't sell very well) think that working from a projected image is cheating. Cheating whom? Cheating at which rule? From which rule book? The opaque projector is an aid to speed, which is important to illustrators who must work within tight deadlines. It helps to improve the painting, just as good paints and brushes do. Of course, some artists try to use the opaque projector to compensate for weak draftsmanship, but weak drawing is always glaringly apparent.

Of course you can use a slide projector to project images, but its use limits you to 35mm slides. The opaque projector can project printed matter and photographs. There are various types, makes, and models, but we need to review only the two popular types of opaque projectors—horizontal and overhead. A horizontal projector projects an image onto a vertical surface—a wall or an easel. The Astrascope 5000 and the Artograph MC 250 have powerful halogen lamps and can handle photos up to 6" x 6" (15 x 15 cm). Horizontal projectors can only enlarge the image; they cannot make reductions. They're perfect for the artist who requires large, tack-sharp images.

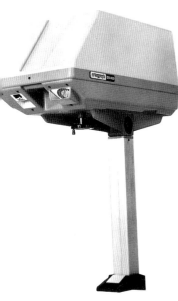

The Artograph DB 400 will accommodate a 10½" x 11" (27 x 28 cm) image and can make reductions down to 33% and enlargements up to 300%. It attaches to the edge of your drawing table.

Overhead projectors can enlarge and reduce images. My favorite is the Artograph DB 400. It will accommodate a 10½" x 11" (27 x 28 cm) image, with reductions down to 33% and enlargements up to 300% (you can project it onto the floor for an 800% enlargement). At 38 pounds, it attaches to your drawing table, so it's always convenient to use. Although I have several opaque projectors, the DB 400 has become the workhorse of my studio.

BRUSHES

For painting with gouache, you can choose from the many watercolor brushes on the market. Although artist's brushes, unlike paints, don't lend themselves to objective evaluation, there are a few simple tests you can use when selecting your brushes. Also, if you understand the function of the brush, you will be able to select more wisely.

A brush is not much more than a bundle of hair or fibers that acts as a reservoir to hold paint and wick it to the tip. Obviously, the more hair, the greater the brush's capacity for holding paint. Of course, the kind of hair is of paramount importance, and the winter coat of the male Kolinsky sable is the sine qua non for watercolor brushes.

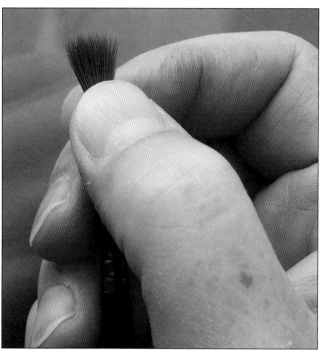

Hold the brush by the ferrule and gently squeeze the hairs apart. This will show how well the brush is made. Look for the brush with the most hair. It will hold the most paint.

The standard by which all sable brushes are judged is the Series 7 brush made by Winsor & Newton. The Series 7 was originally made at the behest of Queen Victoria, who shared her subjects' passion for watercolors. Winsor & Newton set out to produce the very finest brushes ever made. For Her Majesty's brushes, the company bound Kolinsky sable into sterling silver ferrules with ivory handles, which shows that it's nice to be the queen. Today the Series 7 brushes (sans silver and ivory) are made in sizes ranging from #000 up to the spectacular #14 brush, which costs hundreds of dollars. The greatest testament to the superlative construction of the Series 7 is that, no matter how large the brush, it will come to a 000 point.

Until recently, brushes made with synthetic fibers were virtually useless for serious artistic work. The new generation of tapered nylon-filament brushes has much to recommend them. I find myself using synthetic brushes for painting all but the most exacting details. There's less variation between synthetic brushes than those made of sable, but the same tests apply. Synthetics have a unique quality; when they lose their shape and droop, put them in hot water for a few minutes and they spring back to shape. The hot-water treatment also restores their spring. Some manufacturers produce brushes that are a blend of natural hair and synthetic fibers. The best known is Winsor & Newton's Sceptre series. I've used the same Holbein Hira-Fude flat every day for months. Around the studio, it's known as "the brush that will not die."

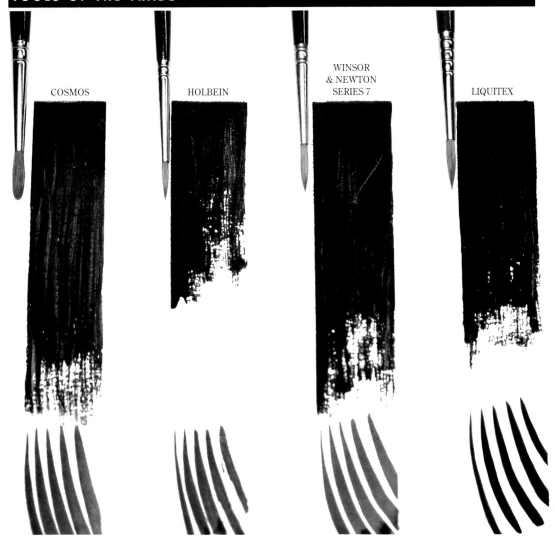

COSMOS HOLBEIN WINSOR & NEWTON SERIES 7 LIQUITEX

Test the brush by fully charging it with paint, getting it to hold as much as possible. Apply all of the paint—drag it out as far as it will go. Recharge the brush and flick the excess paint into a wastebasket. A good-quality brush will resume its natural point.

Testing Brushes for Quality

The market abounds with excellent brushes, and not a few bad ones. Selecting a good brush is not too difficult once you know how. If you hold a brush by the ferrule and gently squeeze the hairs, they will splay out to reveal the amount of hair used in making the brush. Don't forget—more hair holds more paint. You'll find variations within the same line by any manufacturer. The variations are much wider from brand to brand. Price is not an accurate indicator of quality. Some high-priced brushes look good until you gently squeeze the hairs, revealing skimpy construction.

After finding a few brushes that pass the first test, dip them in water, swirl them around to remove the sizing, and with a flick of the wrist, snap the water from them. They should snap to a fine point. Repeat dipping, swirling, and snapping three or four times. Select the ones with the best natural point. Do not get into the habit of pointing up the brush by putting it in your mouth. Some

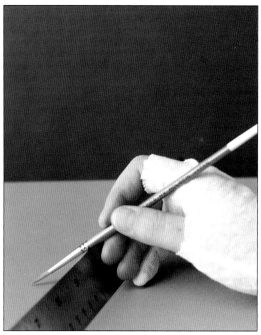

Lines drawn with a brush always have more life than those drawn with a ruling pen. By angling a metal-edged ruler against the support and running the ferrule of a brush along the edge, you can draw a precise line.

By suspending a template over the artwork, you can draw accurate circles and ellipses with a brush. This trick, however, requires lots of practice and a sure hand.

The Holbein RGB is very useful for drawing precise curves with a brush. The rod and brush follow the edge of a French curve as easily as a straightedge.

For straight lines, the brush and glass rod are held parallel to each other, spaced slightly apart. The brush moves across the support as the glass rod rides in a grooved ruler.

pigments are toxic, and putting a brush in your mouth can be more dangerous than putting an X-acto knife in your mouth.

The two most prized qualities in a brush are its capacity to hold a large amount of paint and its ability to snap back to its proper shape repeatedly. I have devised a simple test for both. Lay parallel strips of masking tape across a piece of illustration board, leaving six channels that are slightly narrower than the width of a brushstroke. The channels should be equal in length and width. Mix a generous quantity of liquid paint on your palette and charge your brush with paint. The idea is to get the brush to hold as much paint as possible. In the first channel, apply all of the paint on the brush. Start with a delicate stroke and gradually widen it by applying more pressure—drag it out as far as it will go. Recharge the brush and flick the excess paint into a wastebasket. The brush should assume its natural point. Don't try to draw it out into a point. Repeat this exercise five times, using the remaining channels. It's important that you don't twist or spin the brush into a new position. The purpose of this test is to see if the point will resume its shape from stroke to stroke.

Drawing Aids for Brushes

If your illustration requires lines drawn with mechanical precision, gouache colors can be applied with a ruling pen—not a technical pen, but a double-bladed ruling pen. You can also use a brush to draw straight lines almost as precise as those made with a ruling pen. Lines drawn with a brush always have more life than those drawn with a ruling pen. By resting the ferrule of the brush against a straightedge (I prefer a simple wooden ruler with a metal edge), you can draw an exceedingly precise line. I also use a variation of that technique, suspending a template over the artwork, to draw freehand circles and ellipses. It's a trick requiring lots of practice and a sure hand.

The Holbein RGB may look like another gizmo doomed to gather dust, but it isn't. The RGB kit consists of a plastic ruler with a groove and a glass rod with a ball tip that rides snugly in the groove. With it you can draw not only perfectly straight lines with a brush but also precise curved lines. For straight lines, you hold your brush alongside the glass rod—in somewhat the same way you hold chopsticks. You hold the brush well away from the rounded tip of the glass rod as it rides in the grooved ruler. Where the RGB really comes into its own is in drawing precise curves with a brush. The rod and brush follow the edge of a French curve as easily as a straightedge. The glass rod is also a splendid tool for burnishing cut marks left in the surface of a support by overzealous cutting of a frisket. The RGB is a slick little tool.

COLORED PENCILS

Throughout the demonstrations in Chapter 6, you'll find that I repeatedly indicate using colored pencils to refine areas and edges or to add details. They are the quickest way to add color because they don't need to be mixed like paint. Because of the tooth inherent in gouache, colored pencils can be lightly scumbled onto the painted surface to create interesting atmospheric effects. Although there are three distinct types of colored pencils—water-soluble, pastel, and wax-based—this discussion has been limited to the wax-based pencil.

The most familiar of the wax-based colored pencils is the Prismacolor Pencil line with its 72 colors. Prismacolor pencils lay down a smooth, dense stroke of brilliant color. The only complaint I have ever heard about Prismacolor pencils concerns their annoying habit of breaking at the wrong time. The leads are brittle and tend to break after two or three strokes. Less brittle than Prismacolors are Derwent Studio Pencils. They are available in the same number of colors, but the colors are dull in comparison to Prismacolors. The pencils manufactured by Derwent Studio are not as opaque or as brilliantly colored as those made by Prismacolor.

Every bit as brilliant as Prismacolor but without the brittle leads are Design Spectracolor Pencils. Spectracolor pencils are made in 60 colors and, with their solid black wood barrels, are quite attractive.

SUPPORTS

Your choice of support for gouache is governed by the effect you wish to achieve. Painting on rough watercolor paper gives you highly textured brushstrokes, whereas painting on a hot-pressed surface allows you to produce the finest details. Special care must be shown to gouache paintings executed on hot-pressed surfaces. A smooth, calendered finish doesn't offer as much gripping surface as a cold-pressed surface with its slight tooth. But adding a bit of ox gall or other wetting agent to the water will allow gouache to stick even to acetate and obviously will help it stick to a smooth-surfaced paper or board.

The ideal surfaces for gouache are illustration boards made by Bainbridge, Crescent, and Whatman, which consist of high-quality paper mounted to a stiff backing. Watercolor paper and Bristol can easily be mounted to illustration board with a variety of adhesives. Another support for gouache is a gesso panel, which can be finished to have an absorbent tooth or a slick, polished surface. Although you can paint gouache on canvas, oils and casein are better suited to it. Choosing a support is a highly personal decision that should result from extensive experimentation.

Strippable Boards

Because of the universal shift away from making color separations with the process camera to using the laser scanner, less than flexible paint films pose special problems. In order to be scanned directly, the surface of an illustration board must be stripped from its backing and wrapped around the scanner drum. Although it's done all the time and is perfectly safe with flexible paints like acrylics, such treatment can harm the surface of an illustration done in gouache unless done by a skilled craftsman.

Fortunately, both Crescent and Letramax make strippable board. The surfaces of strippable boards are attached to the backing board with a low-tack adhesive that allows the surface paper to be peeled off easily, placed on the scanner drum, and later repositioned onto the backing. If you prefer a specific paper surface, you can apply a low-tack adhesive to the board and attach your favorite paper. Far and away the best adhesive is Maxon #300 double-sided tape. One side has a high-tack adhesive that attaches to the board; the other side has a low-tack adhesive that allows for easy removal and repositioning of the paper surface. Maxon #300 is expensive but worth the money.

A word of caution: Do not use rubber cement or spray adhesive to attach paper to a board backing. Those adhesives are likely to "set off" onto the scanner drum, resulting in a very unhappy technician.

Improving Flexibility

Thick puddles of gouache left to dry on a palette will crack and chip off easily. Thick layers of dried gouache just aren't very flexible, certainly not as flexible as acrylics. Because of the paint's innate brittleness, care must be taken when rolling up a gouache painting or bending it around a scanner drum.

Illustrators have devised a number of ways to minimize cracking and peeling. The best method is to paint with reasonably thin coats of paint; after all, gouache's opacity eliminates the need for thick layers. Some illustrators make the paint more flexible by adding a small amount of matte acrylic medium to the water. In order to avoid adding too much medium, thus affecting the characteristics of the gouache, they add the medium to the water, not to the paint itself.

Winsor & Newton claims that Aquapasto can be added to gouache as an aid to flexibility. As with most things, moderation is the key to success. In experiments I thinned Aquapasto with distilled water until it was thin and watery and mixed it with my colors. While both the Aquapasto and matte medium did improve the flexibility of the paint film, they destroyed one of the most important characteristics of gouache—its ability to blend. Dried gouache can be blended with a damp brush, which is how you

Adding small amounts of matte medium or Aquapasto to the mixing water will make gouache more flexible. To improve the bond between the paint and the support, you can size the surface with gelatin or prepared size.

get flawless transitions of tone and color. Aquapasto and acrylic medium don't allow gouache to be reworked, or at least not smoothly enough to be of use.

Sizing the Support

You can improve flexibility by sizing the support. A sized surface has a better tooth. Sizing also reduces the absorbency of soft paper. Ordinary household gelatin can be dissolved in hot water and painted onto Bristol, illustration board, or heavy paper. More convenient is Winsor & Newton's Water Colour Prepared Size, which is packaged ready to use. Both gelatin and prepared size dry quickly and help gouache grip the slickest surfaces. Very liquid coats of paint may cause heavy coats of gelatin to combine and change the surface characteristics. Both of these sizes require thorough testing to determine if they fit your working methods.

You may prefer sizing with thinned-down gesso. For that, mix acrylic gesso with an equal amount of water and paint it onto the surface of the support. After it has dried, sand it lightly to unify the surface and to add a microscopic tooth. This improves the grip of the gouache. Best for this purpose is an absorbent gesso. Liquitex makes a good one, but perhaps the most absorbent is Absorbent Ground, a custom product from Golden Artist Colors.

Several years ago our studio developed a technique using gesso to isolate the drawing and add a smooth surface to the support. After applying the drawing to the illustration board, we paint as many thin coats of gesso as needed to cover the drawing. That's right, we paint it out completely. After the gesso dries, we carefully sand it until the drawing starts to appear through the gesso. This is a great way to minimize an overly bold drawing so it won't strike through subsequent coats of paint. Another advantage to this method is that it stops the annoying propensity of graphite to creep through colors. Give this trick a try. I promise you'll love it.

Gesso Panels

Of course you can avoid any chance of chipping and peeling by painting gouache onto a solid support. The big disadvantage for illustrators is that the illustration must go through the intermediate step of being photographed before it can be scanned. Because film hasn't got nearly the color range of paint, many a nuance of color and tone can get lost in this step.

If you decide to use a solid support, double-thick illustration board is an excellent choice, but the most stable support is a gesso panel. Either the traditional distemper gesso made with rabbitskin glue or acrylic gesso provides an excellent surface for gouache painting. The only reason to use distemper gesso seems

Paint several thin coats of gesso over the drawing. After the gesso is dry, sand it until the drawing appears through the gesso. Leave enough gesso to create a smooth finish.

Gesso need not be just white. Shown here is a selection of different colors, tooth, and absorbencies. With the exception of Holbein's special coarse-toothed gesso, all can be applied with spray equipment.

to be its connection to history. Hide glues are inherently more brittle than acrylic emulsions and are subject to the cracking caused by atmospheric changes. Some brands of acrylic gesso accept paint identically to distemper gesso.

Gesso manufacturers have made acrylic gesso for every taste and need. Liquitex makes gesso in a dozen or so colors. Holbein also has a wide range of richly colored gesso, with a metallic gold approaching the look of gold leaf. In addition, Holbein makes white gesso in three grades of tooth: smooth, medium, and coarse. Daniel Smith's Worlds Best Acrylic Gesso is certainly in the running for being the world's hardest gesso. Sanding it with ultrafine #2000 sandpaper will produce a surface like polished ivory. This gesso comes in a small range of colors.

In reading my cautions about gouache chipping and flaking, some artists might say I've overstated the case. After all, there are numerous examples of opaque watercolor being used with success on canvas, paper, and acetate—all flexible supports. Mantegna's distemper paintings were done on canvas, and they're still in great shape after all these centuries. But a close examination of those paintings reveals that they owe their survival to the care the artist used when applying the paint. Thin layers of paint will withstand a great deal more flexing than will thick layers of paint. This is true of any paint, even oil, acrylic, and alkyd, although those paints take longer for their weaknesses to become apparent.

In this chapter we've discussed the materials and tools found in a well-equipped illustration studio, but as much as we may be enamored of them, they are only tools. They work only as well as our skill allows. The next chapter will be devoted to developing skills in handling gouache.

3

BASIC
HANDLING

EARNING TO PAINT with oils can take years. There are many techniques and tricks to master. Watercolor is another medium rightly known for being full of tricks. In contrast to oils and watercolors, gouache is the easiest painting medium for the beginning illustrator to master. It dries quickly and corrects easily, allowing the artist to choose how fast or slowly the painting will be built up. Further, gouache is unequaled for opacity, which is the basis of every technique in this book. While any paint allows you paint a dark passage over a light area, gouache excels at allowing light colors to stand out when painted over dark colors.

Because this chapter is concerned with gouache handling, not color, the lessons are built around gray pigments. Using color would be both superfluous and confusing. After you learn how to mix gouache properly, you will experiment with laying in areas of flat, even tones. Next, you will make your own gray card and practice using it to judge values on halftone illustrations. Then you will learn how to create gradations and blend edges using a variety of techniques—some borrowed from watercolor, oil painting, and airbrush, and one that is unique to gouache. Finally you will discover special techniques for creating textures and lines in gouache.

MIXING GOUACHE TO THE CORRECT CONSISTENCY

T he first and most important thing to learn about gouache is how to mix the paint to the correct consistency. Most of the problems that can arise with gouache—chipping, peeling, and colors drying inconsistently—can be laid to improperly thinned paint. You probably know that overly thick paint will crack. But the pigment in overly thin paint can separate, creating a granular effect.

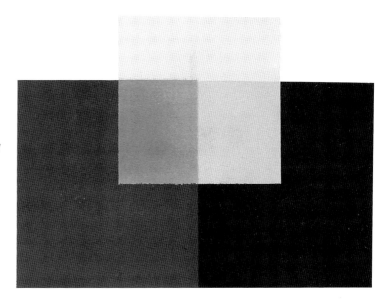

The soluble dyes in some vibrant colors have great staining power, which can strike through from beneath any color. Here Bengal rose has been painted next to primary red. They are overpainted with an opaque mixture of permanent white and cadmium lemon. Even though the yellow mixture covers the primary red, the Bengal rose can be seen striking through.

Hard water can also be the cause of erratic results because it contains chemical salts that can alter colors or cause them to settle out. Although tap water is fine for washing your brushes, use only distilled water when mixing your paints. Most drugstores and supermarkets sell distilled water, which is inexpensive insurance against discoloring and separating. Because gouache dries quickly, you need to add a wetting agent like ox gall to the water you use to dilute your paint. Add about a dozen drops of ox gall to each cup of distilled water.

Mixing gouache to the correct consistency used to be a chore. The consistency of tube gouache varied from color to color and from manufacturer to manufacturer. Today's tube colors are smoother and more uniform in consistency than those of just a few years ago. Much of the improvement is the result of superior packaging. Although not as quaint as bare metal tubes and caps, today's airtight tubes and caps have done a great deal to lengthen shelf life. Unlike oils, gouache is not meant to be used from the tube without being diluted. Unlike watercolors, gouache is not made to be thinned into transparent washes. Occasionally you might dilute gouache to a thin wash, but most of the time you will want to take advantage of gouache's superior opacity.

Poorly mixed paint does not lay down in a smooth coat. Notice the raised brushstrokes, a sign of improperly diluted paint.

The simplest way to determine whether your paint is properly diluted is to note if it dries showing raised brushstrokes. If it shows much texture or dries with shiny and dark streaks, your paint is not diluted enough. Gouache should be applied as a liquid paint, not as a paste. It should resemble thin house paint in its consistency and covering power. A good starting point is to mix two parts of water to one part of paint. When your paint is properly thinned, it will flow smoothly but be opaque enough so that light tones will cover dark—and, of course, dark tones will cover light.

Premixed Grays

For the exercises in this chapter, you will be painting with grays. Although you can mix grays by combining various proportions of black and white paint, it is far more convenient to use tubes of premixed grays. Because gouache is favored by illustrators, who frequently must produce halftone artwork, most manufacturers now include a range of premixed grays among their colors, which offer consistency and save time. With five values of neutral gray, five values of cool gray, and five values of warm gray, Winsor & Newton has the widest range of premixed grays.

Don't be tempted to mix a cool gray with a warm or neutral gray. When you use them in the same painting, it's difficult to properly judge their values. Also, because of the way the camera sees them, cool grays reproduce lighter than warm grays.

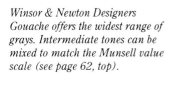

Winsor & Newton Designers Gouache offers the widest range of grays. Intermediate tones can be mixed to match the Munsell value scale (see page 62, top).

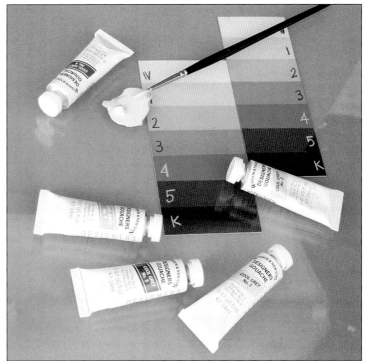

LAYING IN FLAT TONES

By learning to lay in even tones, you will learn to work quickly. Draw a rectangle or square; load, but not to the point of dripping, a brush and fill the area with a coat of paint. In order to get an even tone, try to avoid painting over any areas that have started to dry. You'll have to work quickly to keep the paint wet. Stroke the paint vertically and, while it's still wet, stroke it horizontally to smooth out any brush-marks. Try the same exercise with a lightly charged brush. Notice the difference between the effects you get with a loaded brush and with a lightly charged brush.

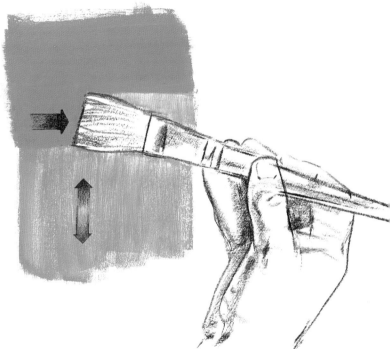

To get smooth and even tones, apply the paint vertically and, while it is still wet, stroke it horizontally to smooth out any brushmarks. Adding ox gall to the mixing water improves the paint's ability to lay down in smooth, even strokes.

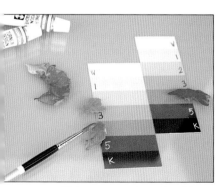

Make a gray scale card and keep it near your palette. Make a habit of locating the values of all your color mixtures on the gray scale.

Do the same exercise again, but this time mix your paint with distilled water to which you have added a few drops of ox gall. It's much easier to get an even tone, isn't it? Now mix a blob of the same paint with well-diluted acrylic matte medium and try the same exercise. If you see much of a shift in the tone, you need more water and less matte medium. Do the same with a thinned-down mixture of Aquapasto and distilled water. A half hour of experimenting will reveal the ease with which you can produce flawless, even tones with gouache—more so than with oils and with greater ease than with watercolors.

Making Your Own Gray Scale

Before we go too much further, let's take some time to make a gray card. You will place the gray card near your palette (or under a glass palette) to keep as a handy guide to mixing proper values. Using the five premixed grays plus black and white will

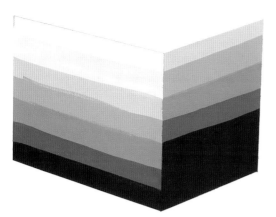

The larger plane has a tonal range identical to the gray card. The smaller section indicates the same plane as seen in shadow. By referring to the gray scale card, you can easily achieve accurate shadow tones.

Every lighting situation is distinguished by the range of contrast between light and shadow. The contrast ranges shown in this chart are accurate depictions of various lighting conditions. You can achieve the same results by cutting your gray scale card in half and sliding each half to its appropriate position.

provide you with seven values. Although you can mix adjacent values to expand the range, why would you want to do it? Many of the best illustrations are done with no more than three main values.

The gray card can be split in half and used as a sliding scale to help determine the correct tones of shadows and lights. If you decide on a strong shadow-to-light contrast range of three values, you can slide one card down until it corresponds to a three-value shift. Thus, a face that is a value 2 in the light will be a value 5 in its shadow. Tones that in the light are values 3, 4, and 5 will all have black shadows. In this strong shadow-to-light contrast range, an object that is a pure white when viewed in the light will have value 3 shadows. The sliding gray scale is one of the most effective means of keeping your values true.

How to Evaluate Values

Sometimes it's difficult to judge values, especially when trying to judge the values of colors. The easiest way to judge values correctly is to cut or punch holes in each of the values of a gray card. Lay the card over the area to be judged and allow that area to show through the holes. When the area seen through one of the holes seems to blend into the gray card, you've identified its value.

It might seem to be difficult to judge the values of colors in the same manner, but it's not. The trick is to throw your eyes out of focus when judging a value. Once you see the color "sink in" to the card, you know its value. You'll be surprised at how often you miss when trying to guess a value without testing it with the gray card. After a month of using a gray card, you'll be astonished at how good your eye has become at judging values. This newfound skill will show in your paintings.

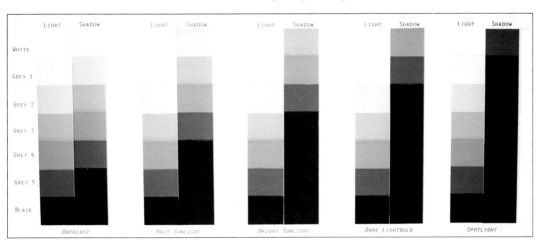

LAYING IN GRADATED TONES

Now that you've mastered flat tones and made a gray card, you are ready to make graded tones. You might think that gouache's rapid drying would limit you to the hatching techniques of egg tempera. But making smoothly painted gradations of tone in gouache is not difficult to achieve. Artists using gouache have borrowed blending techniques from both oils and watercolors and also use a blending technique unique to gouache.

Watercolor Method
The watercolor method of painting into a wet area allows the wet paint to spread and diffuse, creating very smooth transitions of tone. The same approach can be used with gouache. The biggest difference lies in thinking in terms of a solid opaque layer of paint and not trying to thin it into a wash. To achieve smooth gradations, lay in your first area of paint and, while it is still wet, slightly overlap the next tone; the various colors or tones must be already mixed before you begin. Continue with the succeeding tones or colors until the area is fully painted. With this method, I prefer to work from light to dark.

Blending wet into wet can only be done if all of your tones are mixed and ready to use. Overlapping the wet tones allows you blend them easily. This method is particularly appropriate for laying in large, smoothly graded areas.

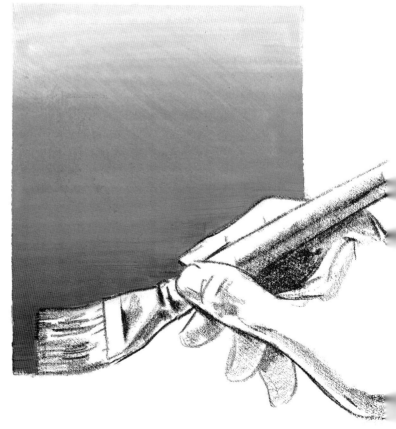

This technique is identical to the traditional oil painting method of making transitional tones. Working wet into wet, you zigzag the edges together and unify them with perpendicular strokes. This approach is useful for controlled blending of small areas.

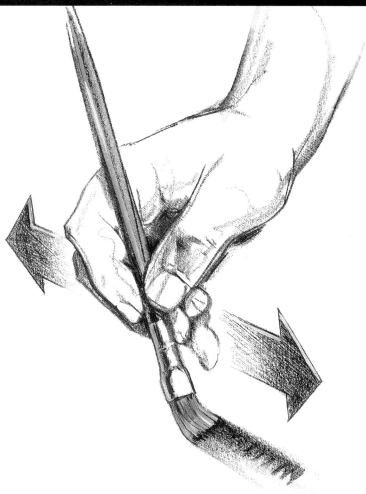

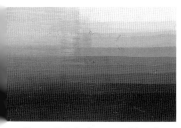

Use a slightly dampened brush to blend areas of dried gouache. The smoothest transitions are achieved by varying your tones in small increments before the blending process. This method produces flawless transitions in tone.

Oil Painting Method

The next approach is identical to the oil painting method of zigzag blending of edges. As in the watercolor method, the paint must be kept wet. Lay down a tone or color and quickly paint another color or tone next to it. Where the two tones join, zigzag your brush horizontally, breaking into the hard edge. Then take a larger brush and stroke it vertically across the zigzag. The result is a flawlessly smooth transition of tone.

Gouache Method

The third method of creating smooth tonal transitions is unique to gouache. Lay several tones or colors next to each other. Rather than trying to blend a value 3 with a value 7 by butting them together and scrubbing away, attempting to create a smooth transition, lay in a series of intermediate tones. Paint small areas of values 4, 5, and 6 between values 3 and 7. Allow them to dry. Using a slightly damp—not wet—brush, paint over and soften the edges. It's just that simple. Because this method allows me to work at a less frantic pace, it is the one I use most often. However, it's important to learn all three blending methods.

Drybrush Method

One of the most controllable methods of blending tones is through the use of drybrush technique. No, the brush isn't actually dry—it's damp with paint. Here's the right way to use drybrush: charge the brush with thin paint and remove the excess by pressing the brush against a piece of paper. This will cause the hairs to fan out. Lightly sweeping the brush across the surface of the painting will deposit soft-edged broken areas of paint. Recharge the brush before it regains its point. When drybrushing, it's important to work with thin paint; full-bodied paint will quickly build up into something resembling a stucco wall.

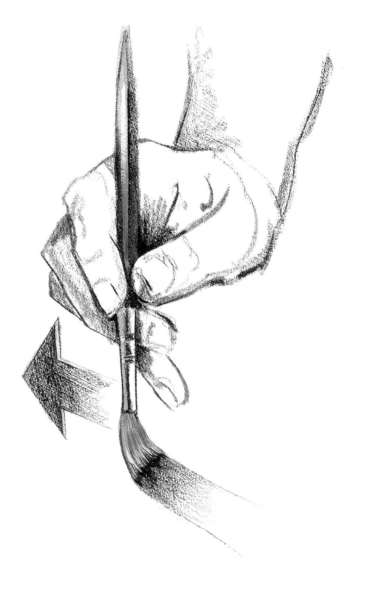

Drybrushing is one of the easiest ways to paint transitions of tone. Drybrush adds visual sparkle to blended areas. Fan out the hairs of a brush that has been loaded with thin paint. Drag the brush lightly over the surface, depositing soft broken areas of paint.

Equal-sized drops of colored ink, gouache thinned for the airbrush, and gouache at the correct consistency for brush painting were laid on an illustration board. The board was tilted so that the colors would drip. Notice that the gouache mixed for the airbrush is almost as thin as the ink.

Airbrush Method

Because of gouache's opacity, it's easy to lay tone over tone with a brush. One of the easiest and fastest ways of applying smooth tones and transitions is with the airbrush. Airbrush and gouache were made for each other. Delicately scumbled highlights are easy to achieve with opaque gouache applied with an airbrush. Glazes and shadows can be painted over gouache using transparent watercolors in an airbrush. Painting scumbles and glazes with an airbrush won't disturb the surface of the painting. In spite of the popularity of premixed acrylic airbrush colors, gouache remains the preferred medium of many top airbrush illustrators.

A flawlessly smooth underpainting made with an airbrush is a joy to work on, either with brush, airbrush, or colored pencils. Gouache can be applied with an airbrush at any stage of the painting process. The airbrush is the perfect tool for indicating halated highlights—those highlights surrounded by a soft glow. Used with watercolor, the airbrush can apply glazes and add transparent shadows to a gouache painting (don't forget, gouache and watercolor are ground in similar vehicles and can be intermixed).

There is, however, an artistic caution that should be noted. Airbrush passages tend to look less substanial than those rendered with a brush. Knowing this tendency, the skilled professional will use it to advantage. If you use the airbrush to render insubstantial and atmospheric effects and use the brush to render objects that have weight and substance, the contrast between the two effects will add power and depth to your picture (see the demonstration of the fantasy illustration on pages 132-135).

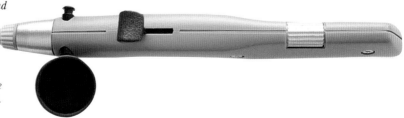

The airbrush is capable of easily producing smooth gradations and transitions. This passage was painted with an inexpensive Aztec 3000S airbrush. The pressure was adjusted to no more than 15 psi. The Aztec is an excellent choice for all but the most demanding airbrush artist.

TEXTURE TECHNIQUES

Gouache can be manipulated in a variety of ways to create textures. Like watercolor, it can be applied with sponges and masked out with resists; in fact, most watercolor tricks also work with gouache. Because of its opacity, it can be painted over like oils and acrylics, and because of its consistency, it can be manipulated with a palette knife and other tools. I have found the following texture techniques particularly useful in my work.

Spatter Method

Perhaps the best-known paint texture is the one we all created as youngsters—spatter. Dipping a toothbrush in liquid paint and scraping the bristles produces a texture that, if used with taste and discretion, can add a great deal to an illustration. As with all textures, the operative word is taste. A highly controlled spatter can be obtained by spraying with an airbrush set at very low air pressure.

Spatter textures can be effective when used with restraint. A toothbrush and a mouth atomizer are inexpensive means of achieving spatter textures. An airbrush set on very low pressure, however, will produce a wider variety of spatter textures. It also gives you greater control of the effects.

Palette Knife Method

Textures made with a palette knife can be of great benefit in decorative illustration and are useful when you are painting realistic and surrealistic landscapes. Layering colors and tones can result in an amazingly solid-looking impasto effect even though the paint is applied thinly. Paint straight from the tube is pressed with a palette knife, but with very little paint sticking to the bottom of the knife. The knife is first skimmed and then dragged over the surface of the painting. The resulting textures are always random and natural looking. They can be overpainted and further refined with brush, colored pencil, or airbrush.

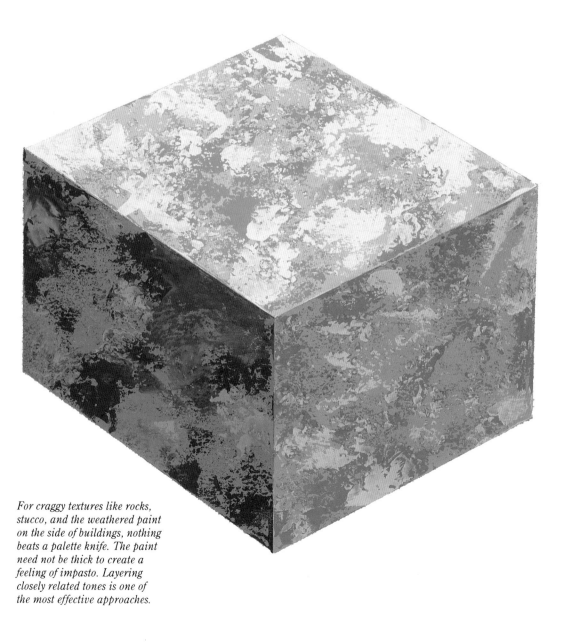

For craggy textures like rocks, stucco, and the weathered paint on the side of buildings, nothing beats a palette knife. The paint need not be thick to create a feeling of impasto. Layering closely related tones is one of the most effective approaches.

Rubber Cement Technique

A somewhat similar texture can be obtained by using a rubber cement resist. For this you need to use the old-fashioned kind of rubber cement, not the one-coat variety. A rubber cement resist texture is easier to control than one made with a palette knife.

To make a resist, just paint a coat of rubber cement over the area to be painted and immediately start dabbing it with a piece of paper towel. As the cement sets up, the paper towel will

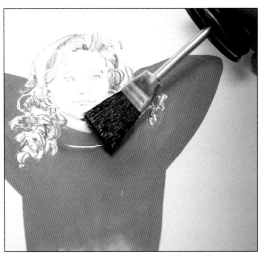

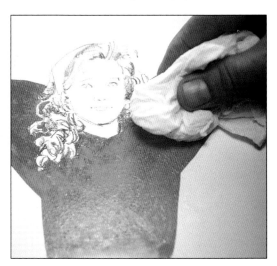

Using a terra-cotta Prismacolor pencil on a small piece of #80 Bainbridge board, I make a quick sketch of my wife while she is relaxing. I paint the sweater with Schmincke cadmium yellow deep, and when it is dry, I add a light coat of rubber cement over the board.

While the rubber cement is still wet, I dab it repeatedly with a wadded-up piece of paper towel. I keep dabbing at it while it dries, removing small bits of the rubber cement.

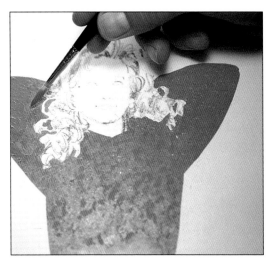

Next, I apply a mixture of Schmincke ultramarine violet and white over the previous color. The rubber cement acts as a resist and the paint takes only in the areas left open.

After the paint is thoroughly dry, I pick away the rubber cement with a rubber cement pickup. I'm very careful not to rub the surface. If the results are not to my liking, I can repeat the entire process with the same colors or different colors and tones.

remove bits of the rubber cement (which will resist, or hold back, the paint), leaving irregularly shaped open areas. After paint has been applied and allowed to dry, the rubber cement is carefully removed with a rubber cement pickup. Try to pick the rubber cement off the surface rather than scrub it away. Scrubbing with a rubber cement pickup can scuff the surface and cause it to take on a shine. The process can be repeated until you've achieved the effect you want.

The rubber cement resist technique is a fast and effective method of adding color to a simple drawing.

LINE TECHNIQUES

S ome of the most useful gouache techniques are the line techniques—that is, methods for painting lines ranging from broken textures to precise rules and curves to crisp lettering. The following techniques are especially useful for the working illustrator.

Negative Space Method

The idea behind this technique is to paint out everything that isn't a line. In a way, this technique exploits the power of negative thinking—thinking about negative spaces, that is.The color of the support determines the eventual color of the line. You can choose a black board or gray or any color you desire the line to be.

Try to apply the lightest pencil drawing possible. Then, using white gouache straight from the tube, paint out the background, leaving the open areas as lines. The dry texture of the full-bodied gouache will cause the brush to skip and drag somewhat as it does for drybrush techniques. Sharp edges and details can be made by thinning the gouache to a more workable consistency. Obviously you are not limited to painting in white only. Charming results can be obtained using color and tone, but the bare bones of the technique should be learned first.

Paint out the background of a sheet of Letramax Super Black board with permanent white straight from the tube. Leave the line areas open. Note the crumbly texture of the line left by the full-bodied paint.

To render sharp edges and fine details, thin your paint to a normal consistency. This is where the superb covering power of gouache is important.

Properly mixed gouache can be balky when you make the first strokes with a ruling pen. Start the paint flowing by drawing the pen across the back of your finger. Once started, the paint will flow without skipping or making blobs.

Ruling Pen Method

As we discussed in Chapter 2, gouache will flow freely through a ruling pen. Don't make the mistake of mixing too much water into the gouache in hope of improving the flow. Not only is that unnecessary, but overly liquid paint has a tendency to leave a blob as soon as the pen touches the paper. Paint of the proper consistency may not flow when the pen is first touched to the surface of the support. In that case the flow needs to be "started" by drawing the pen across the back of your finger. As soon as the paint has been induced to flow, immediately begin drawing.

When the paint dries, you'll notice that lines drawn with a ruling pen are raised above the surface. A ruling pen channels much more paint than a brush; hence the raised lines. Those raised lines can be used to advantage whenever you need to paint sharply delineated areas like lettering. A brush loaded with liquid paint can be "floated" up to the edges of the line. The raised lines act like the wall of a moat, preventing the paint from creeping. A considerable amount of paint can be held in place by capillary action. The lettering will dry to a uniform matte finish, taking on the appearance of high-quality silk-screened lettering. Of course, this technique is useful for all sharply defined areas and is not limited just to lettering.

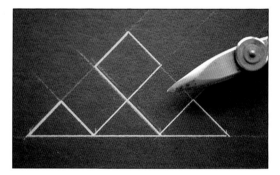

For crisp, flat graphics, the paint can be applied with mechanical drawing tools. Mix the paint thin enough to flow through a ruling pen, but not so thin that it will make blobs.

Using a brush with the same paint mixture, apply the paint so that it butts the edges. Float enough liquid paint into the area to fill the center. Don't worry— surface tension will prevent the paint from spilling out.

When dry, the design is as sharp and opaque as if it had been silkscreened.

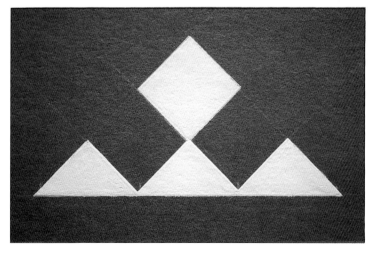

Freehand Methods with Pen

A ruling pen can also be used for freehand drawing. By twisting the pen 90 degrees, you can draw remarkably fluid lines. The blobs left by overly thin paint can be used to advantage. An otherwise simple drawing can take on a lively style when done with a ruling pen and fluid paint (or ink).

Another useful tool for applying gouache is a Speedball pen. Most of us are familiar with the wide range of styles in which the Speedball pen is manufactured. The round and oval nibs are particularly useful. Just remember to clean the pen immediately after use; dried paint is difficult to remove. For a quick fluid line, a Speedball pen is hard to beat.

A ruling pen can also be used for freehand drawing. By holding the pen at a 90-degree angle, you can draw remarkably fluid lines. The blobs resulting from overly thin paint can add a very appealing accidental quality to the line.

MASKING TECHNIQUES

Because of its easily marred surface, gouache cannot be used with every masking tape and frisket film. Gouache painted onto a hot-pressed surface can be picked up by a masking tape or frisket with an aggressive tack. Also, the adhesive used in some tapes and frisket can discolor certain colors. The best advice is, *Always test your materials before using them on an important project.*

The best choice for masking tape is Scotch Magic Plus 811 Removable Tape, a low-tack, ultrathin, clear tape with a matte surface. For a reliable general-purpose low-tack frisket film, I recommend Badger Foto/Frisket Film. For frisketing extremely delicate surfaces, nothing beats Holbein's Toricon SP 100 frisket film. It will not injure the most delicate gouache surface.

I always enjoy working in *grisaille.* Tonal painting allows me to concentrate on the form of the subject matter and on those all-important edges. I hope that you'll continue working in tones of gray if only to make preliminary sketches for your finished illustrations. I'll bet that you're impatient to start working with color. That's the subject of the next chapter, so let's jump into it.

4

COLOR
FOR ILLUSTRATORS

No OTHER FACET of art has more mystery surrounding it than the study of color. From that shrouded mystery, countless color theories have arisen. Some theories have strong foundations built on proven and observable fact. Other theories are, quite frankly, bizarre and impossible to use. In the beginning of this chapter we'll consider a bit of the history surrounding a few of the more bizarre and (unfortunately) influential theories that continue bringing terror to students of color. My opinions may fly in the face of what you've learned in art school or college, but bear this waggish thought in mind—some people can be convinced to sit on a porcupine after it has been exhibited in the Museum of Modern Art as a chair.

The following is intended to relieve you from studying impossible-to-use theories and to introduce you to color theories that you can use, such as the Munsell Color System and the Quiller Color Wheel. In this chapter you will also find practical information on changing the values of different colors, tips on achieving good color and correct tonal values, and a full explanation of the tricky subject of light and shadow. Finally, you will learn how shadows are affected by surrounding color and how to use grays.

COLOR THEORIES THAT DON'T WORK

In the chaos following the First World War, a dissolute Germany became the breeding ground for a new social order. Socialism took firm root in the fertile ground of postwar discontent. Socialist thought crept into everything, even such unlikely areas as the arts. Socialism gave birth to the "artistic manifesto." In their many manifestos, the members of the New Society shouted down figurative painting as merely "illustrating the myths of the intellectual bourgeois." These new anti-intellectuals set about to create artforms that were no more than illustrations of their social and political manifestos.

Out of that curious period came a call to arms issued by the Novembergruppe, one of the newly formed socialist groups: "Painters, Architects, Sculptors, you whom the bourgeoisie pays with high rewards for your work—out of vanity, snobbery, and boredom—hear! To this money clings the sweat and blood and nervous energy of thousands of poor hounded human beings. Hear! It is unclean profit . . . we must be true socialists—we must kindle the highest socialist virtue: the brotherhood of man." Heady stuff. The Novembergruppe was, as Herbert Read said, politicizing the unpolitical.

Apart from founding the Bauhaus, Walter Gropius was also chairman of the Novembergruppe's Arbeitsrat für Kunst (Working Council for Art). He sought to join all of the arts together "under the wing of a great architecture." Appointing himself Great Architect and sounding much like the jackbooted men who would soon follow, he wrote, "The intellectual bourgeois has proved himself unfit to be the bearer of a German culture." He predicted a Bauhaus/Socialist New World Order arising from unsuspected quarters when he wrote, "New, intellectually undeveloped levels of our people are rising from the depths. They are our chief hope." Unfortunately, he got his wish.

A common thread joined the new art forms spawned by this anti-intellectualism. Artistic movements like Futurism, Vorticism, Orphism, Purism and Surrealism were distinguished not so much as aesthetic movements but as esoteric coded languages designed to baffle the hated bourgeoisie. It was only natural that, in those giddy early years, the New Society would produce its own peculiar theories concerning politically correct ways of seeing. Rising out of this yeasty mix of aesthetics and politics and armed with politically correct color theories and a reformer's zeal sprung Josef Albers and Johannes Itten.

Albers's and Itten's color theories had little to do with the practical problems encountered by the figurative artist. To their way of thinking, that was all to the better. When world socialism finally rejected their ideas as counterrevolutionary, they, along with Gropius, beat a hasty retreat to those places still cordial to arcane and unprovable theories—the universities. The hothouse

The color exercises recommended by Albers and Itten, although designed to demonstrate the effect colors have on each other, have no practical value for the figurative painter or professional illustrator.

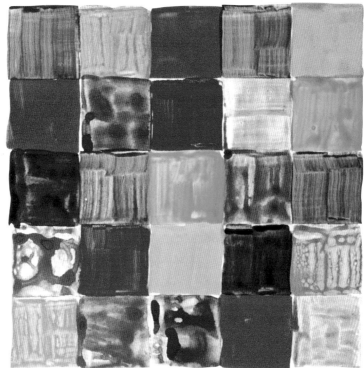

atmosphere of the university provided a congenial rallying place where countless students journeyed to kneel at the feet of their idols. The trouble was those students never got up off their knees; they just went on to repeat those unworkable coded theories to the next generation of easily beguiled students.

Itten's book, *The Art of Color,* attempts to validate his theories through a clever technique used by advertising agencies to sell everything from cigarettes to beer: associate the product with attractive people. By juxtaposing the color charts in his book next to reproductions of the great masters, Itten hoped to lend credibility to his theories. Strangely, he chose painters who died centuries before the advent of the modern pigments shown in his charts. Just as the trim young models in beer commercials are not the result of drinking the advertiser's product, his color theories bear no relationship to those great masters' pictures.

In an attempt to appear original, Itten abandoned the well-proven ten-color wheel of the Munsell Color System (described on pages 60–66) to create an idiosyncratic Twelve-Color Star and seven-value Color Sphere. The dilemma was, How was the artist to apply rigidly circumscribed charts, blocks, stars, and spheres of color to painting the delicate passages inherent in figurative painting? Those uncompromising Bauhaus precepts were coarse, clumsy tools ill-suited to producing the grace and finesse required of figurative painting. To date, the only applications of Albers's and Itten's theories have been in short-lived art fads like color field painting and op art.

COLOR THEORIES THAT WORK

Not all formal color theories are useless to the illustrator and painter. Quite the contrary. Unlike Albers and Itten, well-grounded color theorists like Faber Birren concentrated on practical color effects of use to the artist and craftsman. Birren's book *Creative Color* (1961) should be required reading for any illustrator or painter. The color effects it presents are as extraordinary as they are useful.

Birren was not the only one to have developed practical color theories with the artist in mind. Far ahead of his time was Michel-Eugene Chevreul, whose 1839 book, *The Principles of Harmony and Contrast of Color,* is the fundamental work from which much practical color theory has grown. It was from this book that the color theories of the Impressionists evolved. Although approaching color from a more scientific standpoint, Ogden Rood, Albert Munsell, Wilhelm Ostwald, and Denman Ross all produced work of lasting value to the artist.

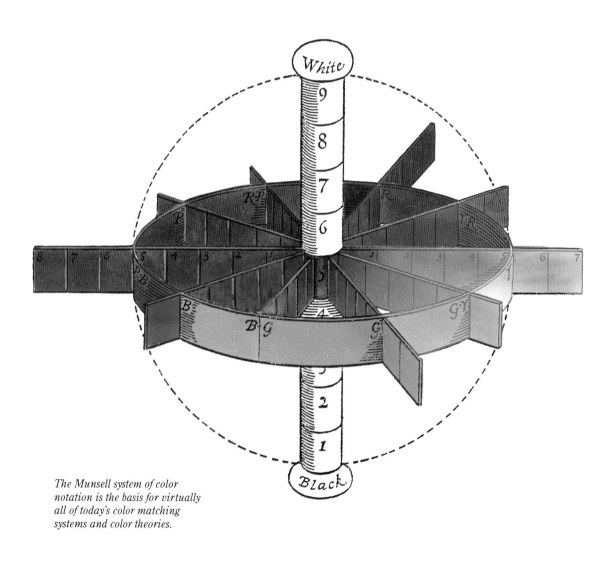

The Munsell system of color notation is the basis for virtually all of today's color matching systems and color theories.

The Munsell Color System

In 1915, Albert Henry Munsell developed an elegant system of color notation in Boston which quickly became the universal standard by which colors are judged. It should also be the standard by which color *theories* are judged. Professor Munsell sought to eliminate from color description such whimsical and confusing names as Firecracker red and Chinese red and to establish a standardized language by which color could be accurately specified. He succeeded in doing much more than that.

HUE
Measurement around a circle

VALUE
Measurement up a vertical pole

CHROMA
Measurement on a horizontal away from a vertical pole

The three dimensions of color: hue, value, and chroma.

Hue: Munsell separated color into three fundamental components. The first dimension was hue, "The quality by which we distinguish one color from another, as a red from a yellow, a green, a blue or a purple." He divided the natural order of the spectrum's hues into ten equal steps on a band. The band was

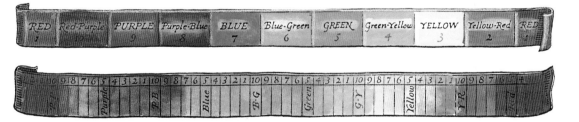

A hue is assigned its position on a band much as it appears in a spectrum. The lower band shows further divisions, with each division of color assigned a specific numerical position.

The color band is bent and joined to form the color wheel.

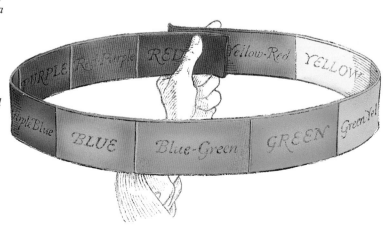

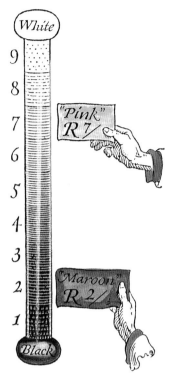

The value scale is depicted as a vertical pole with white at the top and black at the bottom and nine increments of neutral gray in between. The hands hold examples of a red hue that becomes pink as it rises in value and maroon as it drops.

bent around to form a hoop—the color wheel. In naming the hues, Munsell did not use names like orange. What is commonly called orange, for example, he called yellow-red because it is a secondary mixture of those two primary hues.

Value: The second dimension of color is the easiest one to understand. Value is "the quality by which we distinguish a light color from a dark one." The scale used to depict value is a vertical pole divided into nine increments of neutral gray. A pure black was added at the bottom and pure white added to the top.

Chroma: In the Munsell Color System, chroma describes the brilliancy or strength of a specific hue at any given value. By extending a scale horizontally from the neutral pole of the value scale, an easily understood graphic representation of chroma strength can be made. Red is at its most brilliant (has its highest chroma strength) at value 5 on the neutral pole; it extends on the horizontal scale to its maximum chroma strength of 10. As the horizontal scale approaches the pole, the colors become grayer and grayer until, at a chroma strength of 1, they are almost a pure gray. The Munsell system uses shorthand notations in which an abbreviation for the hue is followed by numbers for the value and the chroma strength, separated by a slash.

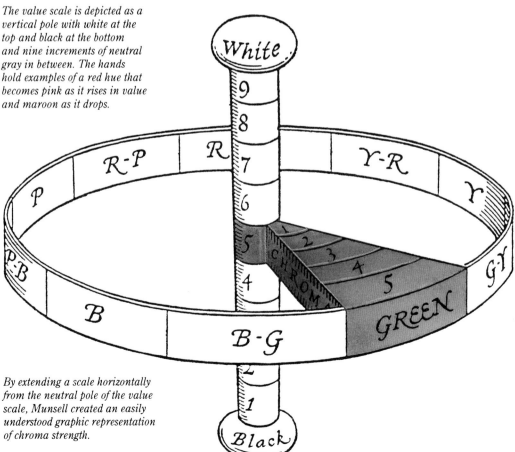

By extending a scale horizontally from the neutral pole of the value scale, Munsell created an easily understood graphic representation of chroma strength.

Different hues reach their maximum chroma strength at different levels on the value scale. For example, yellow is most intense at value 7, whereas purple at value 7 is pale lilac—not very intense. As this diagram shows, purple is most intense at value 4.

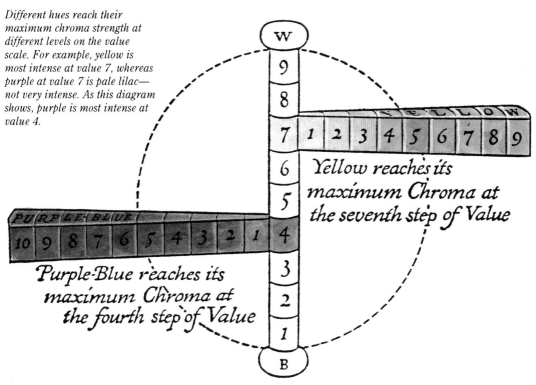

Yellow reaches its maximum Chroma at the seventh step of Value

Purple-Blue reaches its maximum Chroma at the fourth step of Value

Red is most brilliant (has its highest chroma strength) at value 5 on the neutral pole but extends on the horizontal scale to a maximum chroma strength of 10. As the horizontal scale approaches the pole, the colors become neutralized. Notice that the chroma strength of red is twice that of blue-green (at value 5).

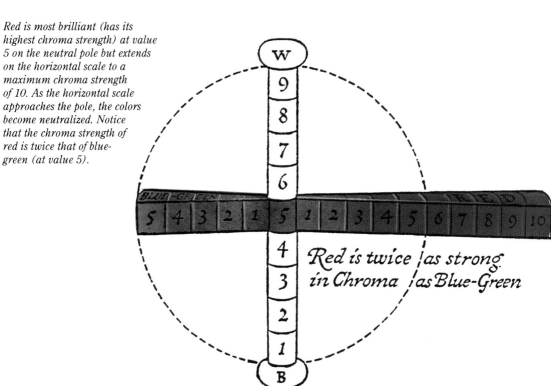

Red is twice as strong in Chroma as Blue-Green

Munsell Applications Today

The scientific principles upon which this system is based are beyond question. Since the inception of the Munsell Color System, hundreds of new colors and pigments have been introduced. Without exception, all of them conform to the system's principles. That is, no color can be higher in value than white or lower in value than black. Every new color has a hue name that can be precisely located on the color wheel. The variable scale of chroma strength can be logically extended to accommodate more brilliant pigments as they become available. For example, when Professor Munsell designed his system, the red hue at value 5 attained its highest chroma strength of 10 (in Munsell notation, R 5/10).

How could the Munsell system accommodate fluorescent pigments, which were undreamed of at the beginning of the century? Quite easily. The complete collection of Holbein Designers Gouache has a fluorescent color called Opera. Its hue is notated as a 7RP, meaning a red with a purple overtone. The value is described as 5.5. Because of Opera's fluorescent pigment, its chroma strength is a whopping 18.5, almost twice that of the original value 5 red. Opera's Munsell notation is 7RP 5.5/18.5.

Complementary colors appear opposite each other on the Munsell Color Wheel. As they approach each other, the tend to become more neutral until they neutralize totally as they meet at the neutral pole.

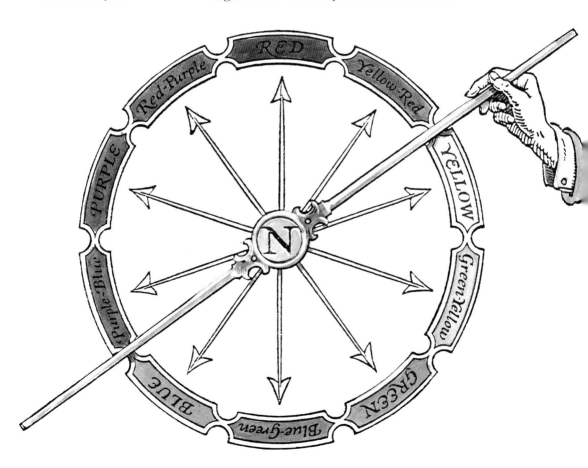

Color Balance

Earlier I stated that Professor Munsell achieved a great deal more than creating a neat system for cataloging colors. Residing within his system is a well-conceived plan for achieving color balance. In comparing the chroma strength of value 5 red with the chroma strength of its visual complement, value 5 blue-green, we can see that although the chroma paths touch at the neutral pole, the chroma strength of red extends to twice that of blue-green. If we mixed equal parts of red with blue-green, we would not get a

Figure 1 shows the inherent lack of balance existing between most complementary colors. Because the chroma strength of red outweighs that of blue-green, mixing equal parts of red with blue-green won't result in a perfectly neutral gray. Instead, it will produce a semi-neutral in which the red predominates.

One way to achieve color balance is by limiting the chroma of an intense color so that it equals that of the dull color. In Figure 2 the red's chroma strength was cut in half to balance the weaker chroma strength of blue-green.

perfectly neutral gray but one in which the red predominated very decidedly. It would be like a tug-of-war with ten men on one side, each representing a step of chroma, and only five on the other side.

Look at the diagrams above with the bar representing the five steps of chroma for blue-green and the ten steps of chroma for red. In Figure 1 the bar rests on a fulcrum at the neutral point and obviously will not balance. But if we cut off steps 6, 7, 8, 9, and 10 from the red side of the bar, as shown in Figure 2, it will balance on the neutral gray. It is this simplicity that is characteristic of the Munsell system throughout.

Of course, as artists we don't want to be limited to using half-strength reds in order to balance their complements. We must have other means at our disposal for attaining balance. If our purpose is merely to make a neutral gray, we simply use a greater amount of the weaker color. If we wish to produce a balanced and

When you want to produce a balanced and harmonious color design, you can employ a larger area of the weaker color. If you do this in the correct proportions relative to the chroma strength of each color, you will attain balance. In this example, 10 parts of blue-green are used to balance 5 parts of red.

harmonious color design, we can employ a larger area of the weaker color. If we do this in the correct proportions relative to the chroma strength of each color, we will attain a simple form of balance. It's as though we used ten blocks of the weaker blue-green (BG 5/5) to balance five blocks of red (R 5/10).

For the artist, most color theories have a major shortcoming; they deal with fabrics, printers inks, and colored lights, not with artist's paints. Chevreul's admirable work was created primarily as an aid to the weavers at the Gobelin tapestry works. Even Munsell's Color System, while it lies at the foundation of modern color theory, does not easily accommodate itself to making accurate mixtures with artist's paints, especially opaque paints like gouache. The colors vary too greatly in overtones from manufacturer to manufacturer.

The Quiller System

Color mixing was made much more understandable in 1989 with the publication of Stephen Quiller's book *Color Choices.* Quiller is an accomplished landscape painter whose work is distinguished by his superior use of color. He mixes color using extraordinary taste and a color wheel of his own invention.

The Quiller Wheel is based on actual artist's paints, not printer's inks. Thus cadmium orange lies opposite ultramarine violet rather than, in Munsell notation, 4 yellow-red across from 9 purple-blue. Although there are variations between manufacturers, the true complements of artist's paints are located on the opposite side of the wheel, thus eliminating color shifts resulting in "mystery mud." Quiller's book and color wheel are the foundation of an easy-to-understand color course.

Stephen Quiller has devised a color wheel based on artist's pigments. It is by far the most practical wheel I have encountered.

TIPS FOR ACHIEVING GOOD COLOR

I won't try to persuade you that learning to use color is easy—it's not—but following these suggestions will help you to keep your paint clean and bright, and that's an important first step toward good color.

❏ Always keep your brushes clean. Use copious amounts of water to clean your brushes. Dirty brushes (and dirty water) will turn the brightest color mousy and dull.

❏ Do not allow the colors on your palette to run into one another. Be especially careful that you do not dip into a color with a brush that contains another color.

❏ Keep your eye on the white paint on your palette. If your brush is contaminated with color, it will show up there first.

❏ Use your gray card to compare the values of your color mixtures. The gray card helps you to get values right the first time and thus avoid overworking the picture. Properly chosen values are the key to convincing color.

❏ Use a color wheel. It will make order out of the chaos. Grumbacher's Color Computer is handy because it helps you to find direct, split, and triadic complementary harmonies. It also shows tints (colors mixed with white), tones (colors mixed with gray), and shades (colors mixed with black). Far and away the most useful color wheel for artists is the Quiller Wheel, illustrated on 67.

❏ Your palette is one of your most important tools. It is where you do your thinking, trying out tones and colors and testing the thickness or thinness of your paint. Your painting can be no better than your palette; keep it clean and organized.

If your brush is contaminated, evidence will first appear in the white paint on your palette.

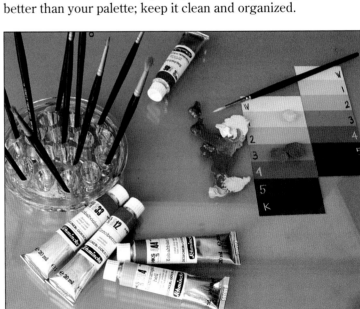

Your palette is where 90% of your thinking is done. Keep it clean. Keep a gray scale handy.

CHANGING THE VALUES OF COLORS

In order to use color in a pictorial painting, you must be able to carry any color from its lightest value down to complete darkness. Although nature contains far darker darks and lighter lights, black and white represent the extreme value range of opaque paints like gouache. Although any color can be lightened or darkened with white or black, that method seldom produces the most brilliant (highest chroma strength) color for any given value.

Yellow

Although you can get a wonderful richness by using black to lower the value of purple, using the same black to lower the value of yellow will produce, not a darker yellow, but an olive green. Lowering yellow's value is easy, however, once you understand that many of earth colors like yellow ochre, raw sienna, and burnt umber are just duller, darker yellows. Because it is located at the top of the value scale, the value of yellow can only be raised with white.

Purple

The various shades of purple, or violet, are very important in creating the shadow areas of its complement—yellow. Don't forget that alizarin crimson is a violet, not a red. Alizarin crimson mixed with phthalocyanine blue produces a dark purple. Alizarin crimson can also be mixed with a small amount of phthalocyanine green to produce a cool violet. Alizarin crimson mixed with a neutral gray produces a wide range of very useful violet tones.

Red

Red can be very difficult to paint with because so many red pigments have cool overtones that are not apparent until you try to mix them with other colors. Cadmium red medium and cadmium red deep turn almost violet when mixed with white. Until you're really familiar with your colors, use cadmium red light for your bright red. When raising the value of cadmium red light, mix a tiny touch of orange into your white to keep it from becoming cool. You can also use flesh instead of white to lighten your reds. In order to maintain the character of cadmium red light while lowering its value, mix it with alizarin crimson tempered with a bit of burnt umber.

Orange

Cadmium orange is the most useful orange pigment. It can be darkened with burnt sienna and lightened with flesh or Naples yellow mixed with white.

Yellow can be raised in value with white. The lower values of yellow are yellow ochre, raw sienna, and burnt umber.

The purest purple is low on the value scale. It can be raised in value with white and lowered with black. Alizarin crimson will cause a shift to red-purple, and phthalocyanine blue will cause it to shift to blue-purple.

Cadmium red light can be raised in value by adding flesh tint or a mixture of orange and white. Mixing red with white will cause it to become cool. Cadmium red light is lowered in value with alizarin crimson and burnt umber.

Cadmium orange can be lowered in value with burnt sienna (in the middle values) or burnt umber (in the lower values). Flesh tint can be used to raise its value.

This scale is mixed from phthalocyanine green and black (at the lowest values) and ranges up through permanent green light and white.

Phthalocyanine blue can be lightened with white and darkened with black or raw umber.

In order to fully appreciate the difference in white pigments, you must make these mixtures yourself. Combine zinc white with flame red to produce a pink. Mix the same value pink from flame red and titanium white. Can you see the difference in the depth of color? Is one mixture chalkier than the other?

Green

Straight from the tube, permanent green light is the highest chroma green. It must be used judiciously in pictorial painting. Phthalocyanine green is very dark but stays brilliant when brought up in value with white. If the lighter mixtures become too cool, mix a bit of cadmium lemon into the white.

Blue

Phthalocyanine blue has extraordinary tinting strength. It's very dark as it comes from the tube, but if you need additional depth to your blue shadows, add burnt umber. Phthalocyanine blue (Winsor & Newton calls theirs Winsor blue) can be lightened with white. Be careful when mixing it with other colors because a little bit of phthalocyanine blue goes a long way.

White

Titanium, or permanent, white should not be mixed with colors unless you want pale, chalky pastels. Titanium white is useful for creating opaque white passages against dark backgrounds. To lighten a color to a clear and bright tint, it must be mixed with zinc white. The virtual unavailability of zinc white in acrylics accounts for much of the chalkiness seen in acrylic paintings when compared to oil and gouache paintings. Although gouache dries to a matte finish, gouache colors tinted with zinc white show far greater brilliancy and depth than similar tints made with acrylics mixed with titanium white.

Black

Artists who have fallen under the thrall of the Impressionists refuse to use black in any color mixtures. Perhaps they've been using the wrong black. Just as some white pigments are better mixers, the same can be said for blacks. Ivory black is the most transparent of the blacks. It can darken colors without over-whelming them.

The most transparent of the blacks is ivory black. It is the best choice for mixing shades of color. This example shows similar mixtures made with flame red mixed with ivory black (left) and with lamp black (right). It is difficult to see the differences in these examples. To understand the differences fully, you must perform these tests yourself.

ACHIEVING THE RIGHT TONAL VALUES

You can get good color in a picture as long as the tonal values are correct. Good pictorial color does not have to represent literal fact. If the value and tonal relationships are right, the color won't look bad. It is poorly chosen values and tonal relationships that spoil more color than anything else. Keep the following concepts in mind:

❏ Pictures that are built on a few basic values—one light, one or two middle tones, and one dark—seldom go dead.

❏ Large amounts of pure, bright colors won't produce brilliant pictures. The colors and values compete for attention, and the brilliancy of the whole picture becomes reduced.

❏ One primary plus its neighbors plus its complementary will never go dead. These colors, supported by neutral and semi-neutral colors plus black and white, will always be brilliant— always.

❏ Make your color mixtures with as few colors as possible. Every color added to a mixture reduces its brilliancy.

❏ Large areas of color should be toned down with a complement or gray in order to give other colors a chance. Remember the axiom *The larger the area, the softer the color needs to be.* Here is an interesting fact: the size of a picture affects our perception of its color harmony. Bright colors can be quite pleasant when used in a small color sketch, but when used in an enlarged version, the same colors appear coarse. The reason lies in the limited number of color cones in the retina of our eyes. Because we have only so many color cones to register different color vibrations, our eye tires quickly when scanning large areas of color. The illustrator whose pictures are photographically reduced for reproduction should understand and exploit this phenomenon.

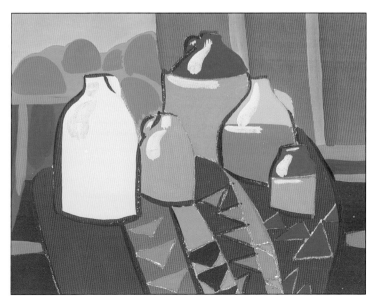

When large amounts of pure, bright colors compete for attention, the brilliancy of the whole picture is reduced.

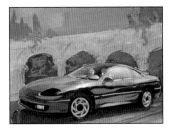

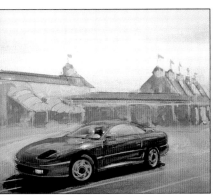

A common cause of dead pictures is too much raw unrelated color rather than not enough. Here are some ways to bring your picture back from the dead:

❏ Try graying all but two colors.

❏ Tie your palette together by mixing a single color into all but one or two of the other colors.

❏ Reduce your palette to three or four basic colors from which you mix all the rest. This is a lot easier and more effective than it sounds.

❏ Don't put bright colors in your shadows.

❏ Put the brightest colors in areas of light, especially transitional areas where light meets shadow.

❏ Never use all three primaries in their pure state in the same picture. Tone two of the primaries with the third one. Only one primary should dominate.

These small color sketches use the palette of split complementaries shown in the example below. I've altered the mood by varying the proportions of cool and warm colors. A limited palette does not limit your color. A limited palette imposes harmony on your paintings.

This palette shows that one primary (blue) and its neighbors (blue-green and blue-purple) opposed by its complementary (red-orange) will never go dead. Notice the variety in the neutral and semi-neutral colors rising from the cool colors at the bottom.

Daniel Tennant's Still Life in Antique Shop *is a splendid example of a picture built on a simple tonal plan of one light, one dark, and two middle values. The tonal plan coupled with the predominant neutrals and semi-neutrals creates an effect far more brilliant than would have been achieved with a patchwork of pure colors.*

❏ Introduce black, white, or gray to help restore the brilliancy of a picture that is too full of color. You have to sacrifice color in one place to gain brilliancy elsewhere.

❏ If the picture doesn't respond to any of the above, the values are wrong. The overall relationship of light to shadow has gone wrong. A color cannot be right until its value is right.

Many of these ideas may run counter to what you have previously thought about achieving good color, but these are not arbitrary rules. They are nature's own rules. Try this: stick your head out the window. What do you see? If your studio is in the city, you'll doubtless see a lot of grays and dull browns. If your studio is in the country, you'll still be looking at lots of grays and browns because most of the permanent things in the landscape—earth, tree trunks, and rocks—are grayed-down colors. Except on golf greens, most grassy areas are grayed or brownish greens. Bright colors are reserved for rare and fleeting effects: flowers, sunsets, fruits, feathers, and the spectacular colors of autumn. Those bright colors always appear to be at their maximum brilliance because they are surrounded and buffered by neutralized tonalities of themselves. Perhaps there's an important lesson awaiting you on your next walk through the fields.

LIGHT AND SHADOW

Outdoor light comes from the sun, not the sky. That's why sunlit highlights are warm, especially at dusk. The blue of the sky reflects into the shadows, causing the shadows to appear cooler than the lights. In a studio with a north window, the opposite is true. Because there is no direct warm light from the sun, the blue of the sky reflects cool light through the window. Because of optical contrast, the shadows appear warm. Your pictures will become lively and lifelike if you create a warm/cool interplay between, and within, your shadows and your lights.

We call the actual color of an object its local color. Yellow is the local color of three of the cubes used in these examples.

Those areas of a yellow cube that are illuminated by a warm light source appear warmer and more intense, while the color on the cool shadow side becomes neutralized.

Place the cube on a blue ground and that color will be reflected up into the shadow. Some of the blue will mix with the yellow, causing the shadows to take on a decidedly greenish overtone.

In this example the local color of the cube is blue. Putting it in the same warm light source that was used in the first example (above left) causes it to become neutralized and to lose brilliancy wherever it is struck by light.

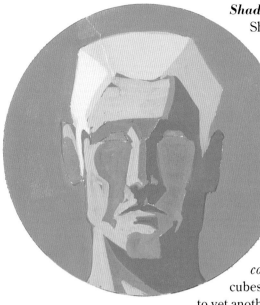

Sunlit highlights are warm, especially at sunset. The blue of the sky reflects into the shadows, causing the shadows to appear cooler than the lights.

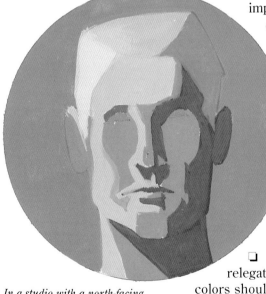

In a studio with a north-facing window, there is never any direct warm light from the sun and therefore the blue of the sky reflects a cool light through the window. The optical contrast makes the shadows appear to be warm.

Shadows Affected by Surrounding Color

Shadows are affected by more than just the warm or cool reflections of the light source. According to our first axiom, *Color is relative to all surrounding influences.* What this means is that the areas of a warm yellow cube illuminated by a warm light source will become warmer and more intense, while the color on the cool shadow side will become neutralized. If we place the cube on a blue ground, the blue will be reflected up into the shadow. Some of the blue will mix with the yellow, causing the shadow to look greener than in the first example.

We call the actual color of an object its *local color.* Yellow is the local color of the first three cubes used in the example on page 76. This brings us to yet another axiom: *Local color should never completely lose its identity in the shadow.*

All colors are modified by the conditions surrounding them. Warm light shining on a warm color will give it greater brilliancy. The same warm light shining on a cool color will subtract brilliancy. The following axioms summarize the most important points to remember about how adjacent color affects shadows.

❏ When struck by light, all colors become a source of reflected light and will reflect themselves into adjacent shadow areas.

❏ All colors in shadow take on the reflected colors of the adjacent light-struck area.

❏ Any two colors become harmonious when one (or both) are mixed with some of the other.

❏ No color can be more intense in shadow than it is in light.

❏ Colors at their greatest intensity should be relegated to the lights and halftones. In shadow, these colors should be grayed or neutralized or changed by the influence of adjacent colors.

❏ The most brilliant colors are usually found in the halftones.

HOW TO USE GRAYS

Although the painter's axiom *Grays make the picture* has much to recommend it, too many neutral grays can deaden a picture. Overly neutralized grays can be fixed by "spiking" them with the color they lean toward. Although this technique is particularly effective in halftones, colors in shadow can also be intensified to good effect. However, to avoid a gaudy and unconvincing picture, you must use greater delicacy and taste when spiking shadow colors.

All of the exercises in Chapter 3 were done with either pre-mixed grays or grays mixed from black and white. Those same grays can be very useful for toning down colors without altering their values. If, for example you hold flame red next to your gray card, you'll see that it falls between value 3 and value 4; my tube of flame red is value 3.5. By mixing increasing amounts of a similar value of gray with the color, you can lower its intensity without changing its value. If you paint a square with the toned-down mixture and place a square of the pure color in the middle, the pure color will appear to be much more brilliant than it would if painted on white. Josef Albers devoted a lifetime to demonstrating the results of this very simple exercise.

Experiment with varying proportions of gray and red. See how easy it is to create the effect of a glowing red area. If you squint your eyes, the differences between the pure color and the grayed color will disappear. Remember, if you photograph this combination with black-and-white film, the entire square will look like it was painted in a value 3.5 gray.

Flame red is value 3.5. By mixing increasing amounts of a similar value of gray with the color, we can lower its intensity without changing its value. If you paint a square with the toned-down mixture and place a square of the pure color in the middle, the color will appear to be much more brilliant than if were painted on white.

Direct complements will usually neutralize each other when mixed together. This chart shows three values of a neutral mixture at the top. The three values in the middle are semi-neutrals favoring one of the colors. The three values on the bottom favor its complement.

Just adding the local color of the lighted area to the darker color of the shadow (which most of us do most of the time) produces muddy transitional tones.

The same color is modified by making it most intense on the edges of the lighted areas, where the color merges into shadow. Notice how it casts an aura of additional color over the whole area.

Visual Grays

Colors that are direct complements—that is, appear directly opposite each other on the color wheel—will usually neutralize each other if mixed together. The neutral and semi-neutral tones made by mixing direct complements are called visual grays. One of the best-known combinations is alizarin crimson and viridian. The chart shows three values of a neutral mix at the top. The three values in the middle are semi-neutrals favoring alizarin crimson. The three values at the bottom are semi-neutrals favoring viridian. The same system applies to the other examples.

Learning to mix and use visual grays is one of the most useful skills a colorist can develop. I spent more than a year painting with nothing but mixtures of ultramarine and raw sienna and never exhausted the possibilities offered by those two colors. Painting with such a limited palette gave me a greater appreciation of color. Again, this is something that must be experienced firsthand. Pick any two complementary colors and execute a painting. Although you may use a full range of values, you'll probably not use a full range of color. You'll find this exercise a real eye opener.

Like many of the techniques in this chapter, the following technique was first shown to me by Andrew Loomis in his classic book *Creative Illustration*. According to Loomis, one of the best ways to make color brilliant is to keep it most intense on the edges of lighted areas, where the color merges with shadow. The effect is that the whole area will take on an aura of extra color.

Most of us just take a local color from the lighted area and add it to a darker color in the shadow, but this does not create brilliancy. Rather, "it is apt to be just color in the light, then mud, then reduced color in the shadow. This is one of the least known and least practiced truths." It also is one of the best and most useful pieces of advice I've ever received.

5

GOUACHE COLOR
RECIPES

BECOMING AN ARTIST re-
quires developing many skills. The skills required
to translate Greek into Latin pale when compared
with those needed to translate a three-dimensional
object onto a flat surface. As superb as they are, the
delicate mixtures and manipulations of a great chef
like Escoffier can't compare to the subtle color mix-
tures and brush handling of a master painter or illus-
trator. To be an artist is to be part naturalist, part
scientist, and part poet. But, lest we get too puffed up
with our own importance, we should remember that
we are also manual workers. We make our living
with our hands.

Of all the skills required for us to develop as illus-
trators, perhaps the most important is the ability to be
a good storyteller. At the foundation of good story-
telling must be a common language, which in art is a
set of visual conventions, or common understandings
of how things look. Because the artist learns visual
conventions as recipes, this chapter presents formu-
las for a variety of subjects. You will find recipes for
different fleshtones and other human features, as well
as for such materials as metal, wood, and water. Once
you master these recipes, you will find that you can
build on them and create new ones that fit the subjects
you paint most often.

VISUAL
CONVENTIONS

To this day, advertisements depict the ideal man as being trim and athletic, having a firm jaw and eyes slightly narrowed from years of manly exposure to the great outdoors. Called the Montana face by sociologists, this image has its genesis in our television and movie heroes. Handsome actors staring stoically into klieg-lit skies have imbedded the image of the Montana face—an artistic and dramatic convention—deep in our consciousness. Most of us never meet real heroes, and so we are usually disappointed by photographs of real-life heroes because they don't conform to our view (the visual convention) of what a hero should look like.

Advertisements create the visual convention of the ideal man being trim and athletic, with a firm jaw and eyes slightly narrowed from years of exposure to the great outdoors—the "Montana face."

When, as illustrators, we must depict a heroic character, we usually opt for a variation of the Montana face. Even if our hero is a middle-aged, balding banker, we add subtle aspects of the Montana face to his face, maybe a determined jaw or narrowed eyes. Of course, we can also manipulate color, line, composition, and countless other elements to reinforce the heroic aspect of his character.

For the artist, most visual conventions are learned as recipes. Because they work, and work well, most of us accept these recipes without giving much thought to the underlying reasons for their use. The following recipes are given with some description of the underlying principles. For the purpose of clarity, the accompanying illustrations were executed in a broad and diagrammatic style that may appear to be a bit flat. In order to clearly show color variations, they contain very little contrast. Once you have learned the underlying principles, doubtless you will want to use a more subtle rendering approach.

FLESHTONES

There exists a great variability in the skin tones of humans. Some people have skin as pale and translucent as porcelain. Others have skin as opaque and black as polished jet. Most of us fall between those two extremes. The following principles are artistic conventions based on generalizations made from observing nature. Once you master the basic principles, you will be able to develop your own variations.

Light Fleshtones

We shall begin with light-colored skin because its areas of color are most obvious. The human face can be divided into three lateral areas of color. The topmost third of the face, which includes the forehead, extends from the top of the head down to the eyebrows. This area is usually half a value lighter than the rest of the face. The middle area, which includes the ears, cheeks, and nose, is most intense in color. Because the blood vessels are closer to the surface, the ears, cheeks, and nose are redder than the other areas of the face except the lips. The bottom third of the face, which includes the jaw, chin, and area under the nose, is most neutral in tone. This is more obvious in men because of beard growth. Let's study each area separately.

Unless you are painting a totally bald person, the forehead is the only fleshtone in the top third. For the sake of simplicity, paint that area with a mixture of yellow ochre and zinc white. You can add a hint of cadmium red light if you feel you need additional warmth. This will be the basic flesh mixture, or base color, from which you will mix all the fleshtones. The forehead is the area of highest value (approximately one-half step of value). For the shadow areas, mix yellow ochre and cadmium red light with a gray of the appropriate value, then cool it down with a touch of a cool green like viridian or, if you wish, a cool purple.

For the central section of the face, add enough red to the base color to lower its value by a half step. Although you can use cadmium red light, the earth-toned light red (English red) or Venetian red will impart greater subtlety. There's a school of painters in New York who, although they produce uniformly excellent pictorial paintings, are less than subtle in their use of red on the face, especially on the nose. This stylistic fillip makes the most serious of their figures appear clownlike or like someone suffering from a cold or, even worse, alcoholic. Although I'm no great champion of subtlety in illustration, I do recommend care when using red on the nose, cheeks, chin, and ears.

The areas under the nose and the jaw are painted the same value as the cheeks and nose but tend more toward a neutral. By mixing your base color with burnt umber, you can achieve the correct look without making the face look as though it's in need of a shave, an important consideration when painting women.

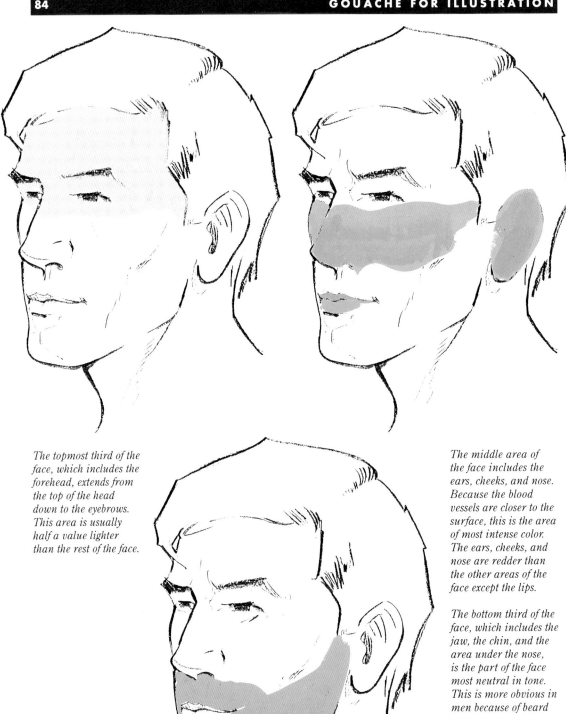

The topmost third of the face, which includes the forehead, extends from the top of the head down to the eyebrows. This area is usually half a value lighter than the rest of the face.

The middle area of the face includes the ears, cheeks, and nose. Because the blood vessels are closer to the surface, this is the area of most intense color. The ears, cheeks, and nose are redder than the other areas of the face except the lips.

The bottom third of the face, which includes the jaw, the chin, and the area under the nose, is the part of the face most neutral in tone. This is more obvious in men because of beard growth.

Paint the forehead with the basic flesh mixture of yellow ochre and zinc white to which you can add a hint of cadmium red light if you need additional warmth. For the shadow areas, mix yellow ochre and cadmium red light with a gray of the appropriate value, then cool it down with a touch of a cool green like viridian. All the examples of fleshtones are painted with Turner Design Gouache.

For the central section of the face, add enough red to the base color to lower its value by half a step. You can use cadmium red light, but the earth-toned light red (English red) or Venetian red imparts greater delicacy.

The jaw and the area under the nose are painted the same value as the cheeks and nose but definitely a neutral tone. You can achieve the correct look by mixing your base color with burnt umber.

Brown Fleshtones

Brown fleshtones are characteristic of most of the world's population, so it's important for the illustrator to learn to paint them convincingly. The basic principles are similar to those for light skin. The major difference is in the color base. Whereas white is the color base for light fleshtones, a darkened white is the color base for dark-skinned people.

The color base for brown skin is made by mixing burnt umber and burnt sienna into white. Mix it to approximately a value 4 on the Munsell neutral pole or a Winsor & Newton gray #2. Mix it lighter or darker depending on the depth of your subject's skin tone. Replacing the burnt sienna with yellow ochre will give you a good base color for many Asian skin tones. A little viridian may be needed with the yellow ochre. A good point to remember is

The color base for brown skin is made by mixing burnt umber and burnt sienna into white. Mix it to approximately a value 4 on the Munsell neutral pole or a Winsor & Newton gray #2. Mix it lighter or darker depending on the depth of your subject's skin tone. The darker the skin, the higher the contrast of the highlights must be. They are cool highlights, so mix white with a small amount of cerulean blue or spectrum violet and mix the resulting tint into your base color.

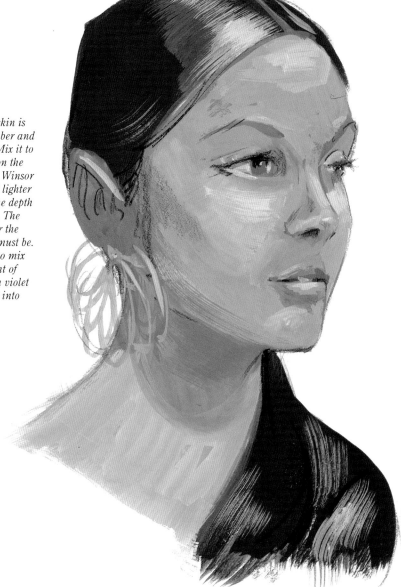

that Asian skin, as well as many olive complexions, has less variation of color and tone than light skin.

Into the darker base color, mix the same colors you mixed with white in order to get light skin tones: yellow ochre, red, and so on. To make shadows, add alizarin crimson and a hint of phthalocyanine blue to these colors. Most beginners make dark brown skin lighter than it actually is in the hope that the lighter tones will allow them to capture nuances. Go for the depth and richness of tone, and the nuances will take care of themselves. The darker the skin, the higher the contrast of the highlights must be. Also, they're cool highlights, so mix white with a small amount of cerulean blue or spectrum violet and mix the resulting tint into your base color. Don't forget to tone down the whites of the eyes (see page 91) and bring them more in line with the warmth of the skin tone.

Replacing the burnt sienna in the previous base color with yellow ochre will give you a good base color for many Asian skin tones. A little viridian may be needed with the yellow ochre. I have minimized the color variation and contrast in this example as an aid to clarity.

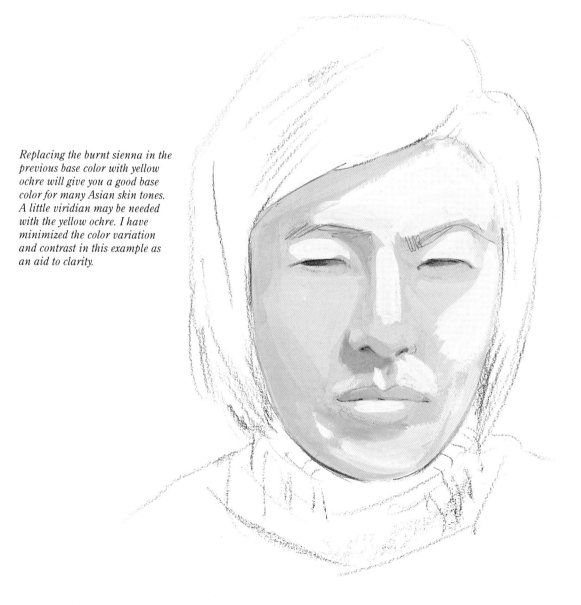

Black Fleshtones

Although I've never had any problem depicting brown-skinned people, I used to have difficulty capturing the skin tones of black Africans using my three-tiered fleshtone approach. After much study I found that Nubian black skin is so dark that it is best handled like a reflective surface, more like metal. There may be other methods, but this one works for me.

Instead of dividing the face into three lateral areas of color, divide it into highlight, halftone, and shadow. Mix phthalocyanine blue and raw umber together and paint this dark color into the halftone areas. The shadows are painted in with Winsor & Newton's Havannah lake or a mix of burnt umber and alizarin crimson. This should give you a shadow area that is lighter in value than the halftone area. The highlights are painted with phthalocyanine blue and white (a Munsell value 3 or 4). Once the three areas are blocked in, go back into the dark halftone area and bring up warm and cool details, trying not to raise the value. As long as the drawing is right, it's almost impossible to go wrong with this technique.

To capture the look of black skin, I divide the face into highlight, halftone, and shadow. Mixing phthalocyanine blue and raw umber together, I paint this dark color into the halftone areas. It looks wrong, doesn't it?

I now paint in the shadows with W&N's Havannah lake or a mix of burnt umber and alizarin crimson. This produces a shadow that is lighter in value than the halftone area. It's still hard to see where this painting is going. In essence, I'm blindly applying prescribed colors to their assigned areas. It looks like I've really messed up.

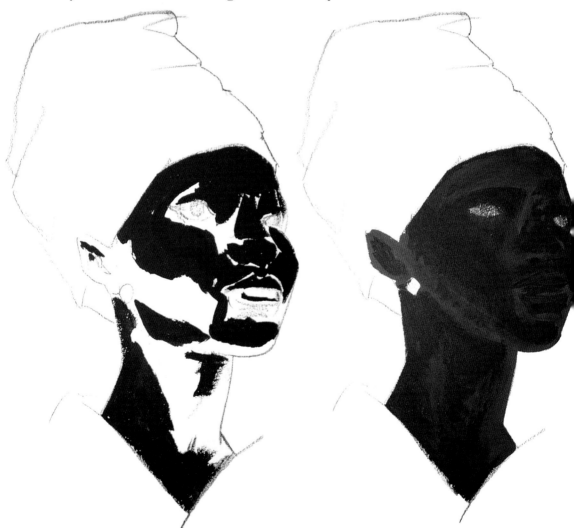

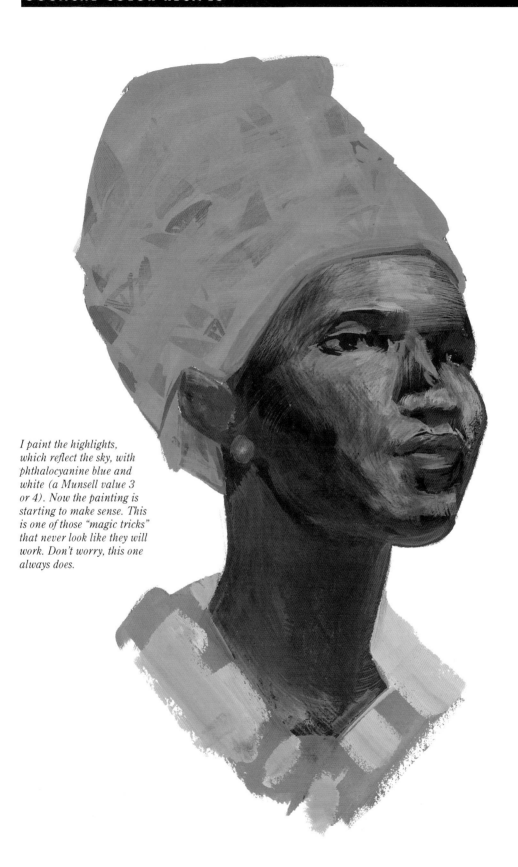

I paint the highlights, which reflect the sky, with phthalocyanine blue and white (a Munsell value 3 or 4). Now the painting is starting to make sense. This is one of those "magic tricks" that never look like they will work. Don't worry, this one always does.

Women and Children

Another long-standing visual convention is to paint women's skin one full value lighter than men of the same racial subset. The same rule holds with children. You can put a bit more red into the cheeks for children but avoid overdoing it. Don't make your fleshtones so light that the highlights won't stand out. Also, don't use a pure white in the highlights on flesh; mix in a small amount of cadmium yellow light and alizarin crimson. You can use a slightly grayed white for the catchlights in the eyes and on the tip of the nose. Because of its opacity, I prefer permanent white for painting catchlights.

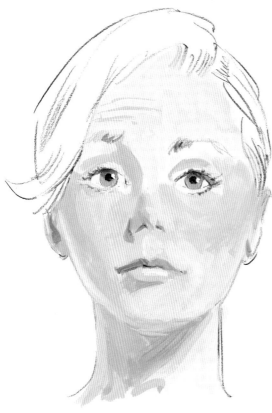

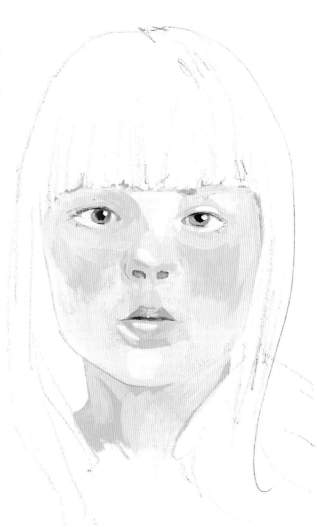

Do not forget that women are painted one full value higher than men of the same racial subset. Once you have mastered the color variations, you will no doubt want to paint with more tonal contrast between the shadows and highlights.

Children, like women, are painted one full value lighter than men. You can put a bit more red into children's cheeks, but use discretion.

The Whites of Eyes

The whites of the eyes are not white—they're gray. If the subject is looking directly at the viewer, you'll notice a bit of white showing on each side of the pupil. That's two white sections in each eye, for a total of four. If you look closely, you'll notice that no two areas are the same shade of white (gray). Mix a different tone for each of them.

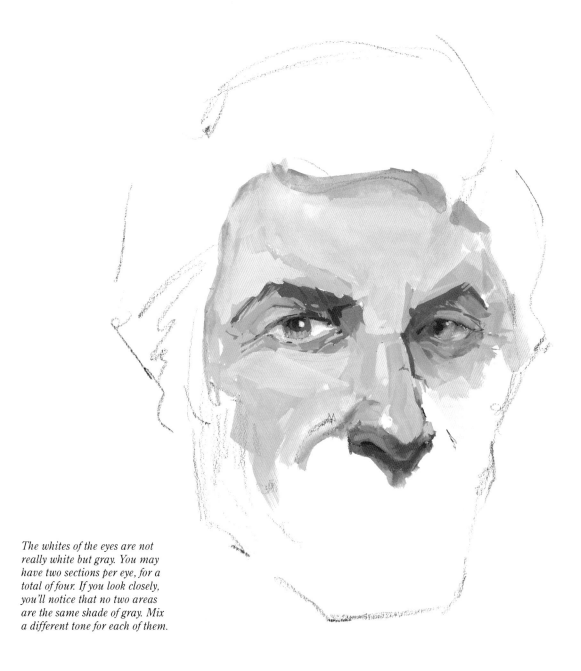

The whites of the eyes are not really white but gray. You may have two sections per eye, for a total of four. If you look closely, you'll notice that no two areas are the same shade of gray. Mix a different tone for each of them.

Beards and Necks

When indicating the beards of men, tone down the basic flesh mixture with a gray to which a touch of alizarin crimson has been added. The mixture should take on a definite violet tinge. Whatever you do, don't stipple little black whiskers into the bearded area.

One sign of an unskilled painter is a badly painted neck, so take care when painting it. A poorly painted neck makes the face appear to float or, worse, look like a mime's face. Under the jaw, paint the neck in the same neutral tones as the jaw. The cast shadow can be made with the appropriate gray, yellow ochre, alizarin crimson, and a touch of viridian. More color should be added to the neck as it recedes from the jaw.

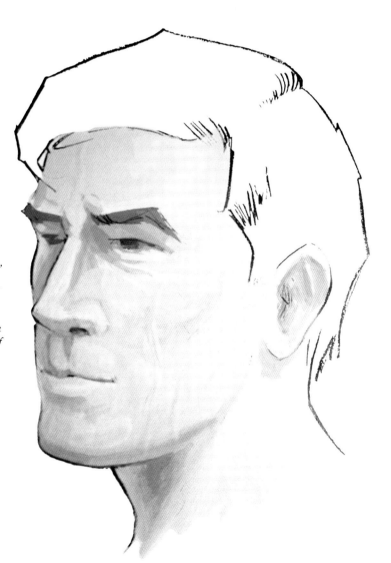

To paint the bearded area of men, tone down the basic flesh mixture by adding a gray mixed with a bit of alizarin crimson, so that it has a definite violet tinge. Compare this to the color used in same area in the illustration at the bottom of page 85. You may prefer one to the other—the choice is yours.

HAIR

Badly painted hair usually resembles a furry animal sleeping on the subject's head. Badly painted hair always looks separate and wiglike, never actually attached to the head. The secret of attaching hair to the head is to paint a transitional zone with a mix of shadow color (gray with alizarin crimson and cobalt blue) at the area where the hair joins the forehead. The transition from forehead color to shadow should be very smooth.

Block in the hair's base color to the edge of this transitional area. Using a drybrush technique, drag the base color into the transitional area and toward the forehead. In other words, paint in the reverse of the direction of growth.

Because the edges of a head of hair are soft transitional tones, leave the hair until last. Paint the areas of the face and the background into the hair area. This will allow you to bring the soft edges of the hair out into the background and the face.

Paint a transitional zone with a mix of base color and shadow color (gray with alizarin crimson and cobalt blue) at the area where the hair joins the forehead. The transition from forehead color to shadow should be smooth.

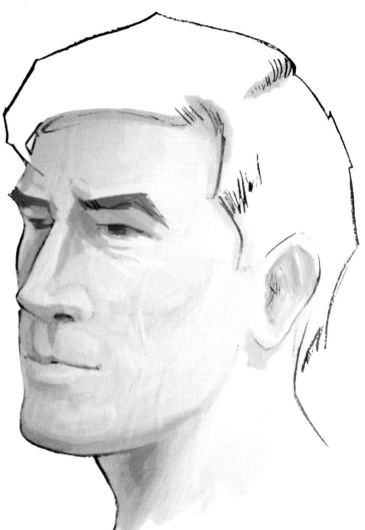

Black Hair

To paint black hair, make a mass tone of ivory black, burnt umber, and a bit of white—approximately a value 7 on the Munsell neutral pole. Don't paint all the way into the background and face areas. For the shadow areas, add burnt umber and phthalocyanine blue to the mass tone. Make the highlights from a mixture of ivory black, white, and ultramarine blue. If you want violet highlights, you can use alizarin crimson instead of ultramarine blue. Use a slightly dampened brush to drag the tones together.

Drag the dark tones in the same direction as if you were combing the hair. For this operation, I prefer a bristle brush slightly dampened with dark paint. Sharp-edged highlights in the hair make it look slick and oily. A smooth transition will give the highlight the natural sheen of hair.

For black hair, mix a value 7 mass tone of ivory black, burnt umber, and a bit of white. For the shadow areas, add burnt umber and phthalocyanine blue to the mass tone. For the highlights, use a mixture of ivory black, white, and ultramarine blue.

Use a dampened bristle brush to drag the tones together. Drag the dark tones in the same direction that you would comb the hair. Increasing the contrast between the darks and the highlights will cause the hair to appear shinier.

Blonde Hair

Although the colors are different, the same principles apply to painting blonde hair. I prefer a greenish mass tone made with cadmium yellow light and Winsor gray #2. Block in the shadowed areas with cadmium yellow medium and burnt umber. Paint in highlights made with a mixture of permanent white and a bit of yellow ochre. I drag the tones together with a bristle brush. Blonde hair usually requires a few extremely pale highlights dragged in with a damp bristle brush.

All colors are blocked in; do not attempt to smooth the transitional tone. The shadow areas are a mixture of cadmium yellow medium and burnt umber. The main halftone area is a greenish mixture of spectrum yellow and gray #2. The highlight is mixed from permanent white with a touch of yellow ochre.

The warm shadows and the highlights are stroked into the cool halftones with a dampened bristle brush. Stroke in the direction of the hair growth.

METAL AND OTHER REFLECTIVE SURFACES

Daniel Tennant's Still Life with Open Book *is a splendid example of reflective surfaces painted with gouache. Observe the range of color that Tennant puts in the reflections on the silver. This painting was done with Winsor & Newton Designers Gouache on a 40" x 50" (100 x 125 cm) piece of illustration board.*

The ability to expertly render reflective surfaces like metal, glass, water droplets, and highly polished automobiles will dazzle everyone. As impressive as these effects are, they are just as easy to paint once you understand the principles. The key to understanding these effects is to approach them as though you were painting an image reflected in a distorting mirror. The image might be bowed or twisted by the mirror, or its color might be distorted. It might be barely reflected, as if the mirror were dusty. Some reflections are a combination of these effects.

To experiment with distorted reflections, wrap a sheet of silver Mylar film around various shapes. Then draw what you see, not what you know. You'll soon find that you're not drawing the object itself but a reflection of its environment.

The two examples shown on page 98 were painted in exactly the same location—on a brick column in my summer studio. If you look closely, you'll see the reflections of three white columns on the left. You'll also make out some trees and shrubs. The reflections are clearest in the chrome sphere, but an impression of them can also be seen in the dull metal sphere. Reflections are difficult to paint because they don't seem to make much sense until the last stroke is painted. In order to paint convincing reflections, you must trust your eyes.

Chrome and Silver

Probably every artist has used the cliché formula for painting chrome—a black horizon over a warm brown that fades to yellow ochre. And above the horizon, a pale blue that gradually darkens as it approaches the top. It's a reflection of a featureless plain, like a desert or beach. There is nothing wrong with that formula except that every sign painter and auto body shop does the same thing.

If you've never painted a chrome reflection, starting out with that formula is a good idea. Once you understand the principles, you'll be able to render reflective surfaces with any colors. Introducing purple into the sky will give your rendering a great deal more depth. Once you are on a roll, try rendering the reflection of a sunset or a night sky with silhouettes of trees breaking the horizon. It should be apparent that there is a great deal of flexibility in painting highly reflective surfaces.

The horizon line doesn't need to be that of a desert; it can be as small as the edge of a table. If you were to render a chrome cylinder that had two chrome rivets imbedded in the surface, the cylinder would reflect the horizon according to its cylindrical shape, and each rivet would reflect the horizon according to its hemispherical shape. The cylinder and each rivet would contain its own horizon line. Just keep the contrast strong, and it will look like chrome or silver.

For painting silver in a still life situation, Helen Van Wyk offers this suggestion: lay in the mass tone of silver using the complementary of the background. For example, if her background is green, she makes the mass tone the violet-gray that results from mixing alizarin crimson with gray. Her shadows reflect more of the green, although she neutralizes the green with more alizarin crimson. She puts lots of green into the highlights, adding viridian and cadmium yellow light to a light gray. Of course, nearby objects are reflected in their local color.

One of the master painters of silver, Daniel Tennant, has done a demonstration that appears on pages 136–141. It contains everything you need to know about painting highly reflective surfaces.

The cliché formula for chrome (top) shows a reflection of a featureless plain, which is not too convincing. Much more effective is the reflection of a sunset (middle) or night sky (bottom).

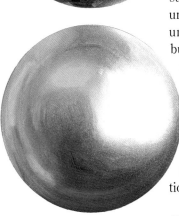

The chrome surface (top) and dull metal surface (bottom) were painted with the same colors. The difference is in the contrast and sharpness of the edges. More contrast and sharper edges create the illusion of polished chrome or silver. Less contrast and softer edges create the illusion, depending on color, of pewter, aluminum, or lead. All the examples of reflective surfaces were painted using Schmincke HKS Designers Gouache, a Liquitex #3 brush, and an Iwata HP-C airbrush.

Dull Metal Surfaces

In many ways the principles used in rendering highly reflective surfaces underlie the rendering of dull metal surfaces. Rather than reflecting like a mirror, dull surfaces scatter light. Therefore the edges of the reflections are softer and the contrast is considerably less than on chrome and silver. Dull surfaces interpose their own local color into their vague reflections. The areas of highest contrast on a dull metal are always in the dents and gouges in its surface.

By graying your colors, you can paint the look of dull metal surfaces. To paint pewter, make a mass tone of gray # 3 and burnt umber. For the shadows, add ultramarine blue and more burnt umber to the mix. For the deepest shadows, add even more burnt umber to the shadow mixture. A touch of alizarin crimson mixed into lots of white will give you the pinkish highlights that are characteristic of pewter. If any objects are reflected in the pewter, simply mix their local color with the mass tone.

To render aluminum, use raw umber in place of burnt umber and make your highlights with a microscopic amount of phthalocyanine blue added to white. Highlights should be softly graded, with a penumbra surrounding them. All transitions of tone must be very smooth and gradual.

Copper

There are two ways to paint copper: by laying in the mass tone first and then adding the shadows and highlights, or by painting the highlights first and then adding the mass tone and shadows. Because of gouache's opacity, both methods work quite well. Lay a mass tone of cadmium red light, burnt sienna, and a bit of white over the entire area. Make the highlights out of white with the addition of some cadmium red light and a little cadmium orange.

To make the penumbra surrounding the highlight, mix the highlight mixture with the mass tone. Mix several values and apply ever-larger circles of diminishing value until the penumbra blends with the mass tone. Smooth the edges with a damp brush. Now add shadow tones made with burnt sienna and ultramarine blue. Add alizarin crimson and burnt umber to burnt sienna for the dark orange areas. Paint in the darkest accents by adding ultramarine blue to the last mixture.

The second method of painting copper is very fast and effective. First paint in the highlights with a pale pink mixed from cadmium red light, cadmium yellow light, and white. Add more cadmium red light and cadmium yellow light, and darken the highlight color to paint in the penumbra. Then add burnt sienna to the mixture and use it as a mass tone. Finally add ultramarine blue and paint in the shadows. This is a quick method because you add color to each previous mixture, decreasing its value.

A good way to paint copper is to lay in a mass tone of cadmium red light, burnt sienna, and a bit of white over the entire area. In this example, we begin by painting just the bottom of a little copper watering can.

Next, paint in the highlights with a mixture of white, cadmium red light, and a little cadmium orange. To make the penumbra surrounding the highlight, mix the highlight mixture with the mass tone. Mix several values and apply ever larger circles of diminishing value until the penumbra blends with the mass tone.

The shadow tones are made with burnt sienna and ultramarine blue. Mix alizarin crimson, burnt umber, and burnt sienna for the dark orange areas. Paint in the darkest accents by adding ultramarine blue to the last mixture.

Gold and Brass

Gold has long been a favorite of pictorial painters, probably because it's so easy to paint. First mass the entire area in with raw sienna and a hint of cadmium yellow medium. Then paint in the highlights with a mixture of Naples yellow and a little white or a mixture of white, cadmium yellow light, and cadmium orange. To make the gold look shiny and convincing, you must add dark tones to contrast with the highlights. Mix alizarin crimson and ivory black into your mass tone and paint the dark areas. The brightest areas of color are the midtones, which are made with cadmium orange and cadmium yellow medium. They

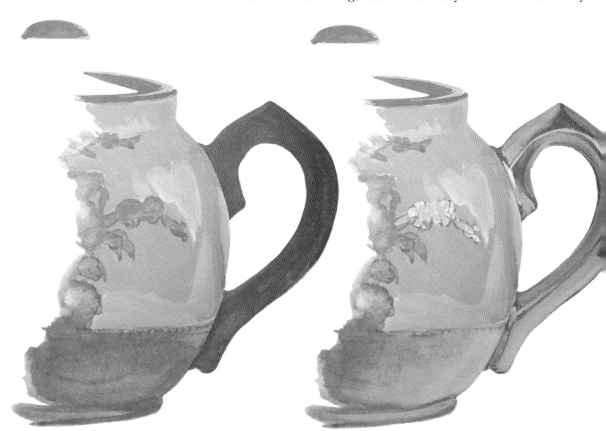

Whenever I sit down to work, my teapot is never far away. To paint its metallic gold decoration, I started by massing the entire area with raw sienna and a hint of cadmium yellow medium.

I now paint in the highlights with a mixture made of Naples yellow and a little white or a mixture of white, cadmium yellow light, and cadmium orange.

should be lower in value than the highlights. Any reflected colors should be mixtures of the color and the mass tone. Reflections can never be lighter than the highlight.

Brass differs from gold in having greenish overtones. The mass tone is a mixture of cadmium yellow light and burnt umber. For shadow areas, mix the mass tone with ivory black and alizarin crimson or ivory black and purple lake. Use straight burnt umber for the darkest accents and, for the shiniest effect, place them close to the highlights. Use cadmium yellow light and white to render the highlights. Paint the reflections following the same procedure in the recipe for rendering gold.

To make gold look convincing, you must add dark tones to contrast with your highlights. I prefer to mix alizarin crimson and ivory black into the mass tone to paint these dark areas. The tones are smoothed by running a damp brush over them.

Brass has greenish overtones, whereas gold is warm. The mass tone of brass is a mixture of cadmium yellow light and burnt umber. The brass of this antique oil pitcher infused every reflection with greenish overtones.

For shadow areas, mix the mass tone with ivory black and alizarin crimson or ivory black and purple lake. Use straight burnt umber for the darkest accents and, for the shiniest effect, place them close to the highlights.

Use cadmium yellow light and white to render the highlights. To show another aspect of brass, I added the matte-finished Florentine banding.

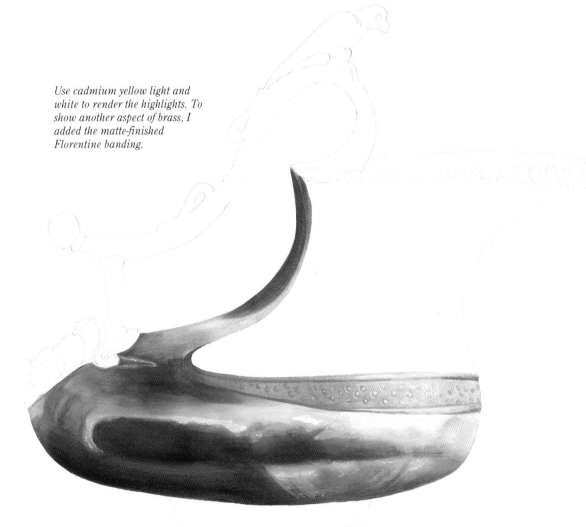

Water

Painting water, dewdrops, and other liquids is easy to do and fun. Mix a tone slightly darker than the background and mass in the shape of the drops. Lay in a subtly graded shadow area inside the front of the drop and lay in a darker cast shadow at the rear of the drop. At the rear of the drop, on the inside, lay in a softly graded reflected highlight. The soft gradations are easiest to accomplish with an airbrush. Paint a bright, sharp catchlight on the graded shadow at the front of the drop. That was easy, wasn't it?

To paint dewdrops, mix a tone slightly darker than the background and mass in the shape of the drops.

Lay in a subtly graded shadow area inside the front of the drop and lay in a darker cast shadow at the rear of the drop.

At the rear of the drop, lay in a softly graded reflected highlight. Paint a bright, sharp catchlight on the shadow inside the front of the drop.

WOOD, MARBLE, AND GLASS

Wood and marble are very easy to render convincingly. The technique is virtually identical to that used by decorators painting *faux bois* and *faux marbre*. There is an extraordinary range of effects and recipes shown in the decorating books written by Isabel O'Neill and Jocasta Innes. I advise you to consult those books for variations on these recipes.

Wood

You can get a woodgrain effect by laying in an area of brown body color and scribbling in the darker sections of the wood with a darker tone (the best way to make the woodgrain convincing is to study examples of the actual wood). Soften the transitions with a damp brush stroked in the natural direction of growth. The easiest way to add highlights is with an airbrush. A good way to paint delicate and transparent shadows is with glazes of watercolor applied with an airbrush. Although glazing watercolor on a gouache painting is very difficult to do with a brush, it's a snap with the airbrush.

Marble

This book cannot begin to show all of the techniques used for painting the wide variety of marble. The demonstration on page 106 shows the basic techniques used to paint a polished stone surface. Again, if you want to add a range of these textures to your repertoire, study the books by the previously named authors. If you're at all like me, you'll be decorating any surface that doesn't move (here's your chance to have a telephone that looks like it's made of serpentine marble).

Glass

Transparent surfaces like glass and plastic are as easy to render as they are impressive. Once you master the techniques shown in the sequence of illustrations on page 107, you will be able to analyze and apply your knowledge to more complex shapes.

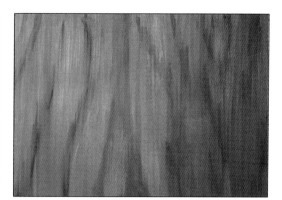

To create woodgrain effects, lay in an area of brown body color and scrub in the darker sections with a darker tone.

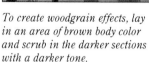

Soften the dark areas with a damp brush stroked in the natural direction of growth.

The easiest way to add highlights is with an airbrush. A good way to paint transparent shadows is with glazes of watercolor applied with an airbrush. The dark shape represents an object blocking the light and casting a shadow. The shadow is airbrushed in with a thin mixture of Grumbacher Finest Payne's gray and raw umber watercolor.

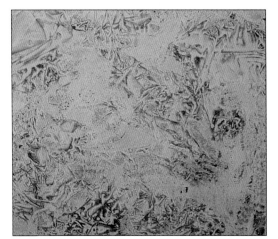

To paint serpentine marble, start by laying in a background area of black. To prevent the black striking through subsequent layers of color, I use Turner Acryl Gouache jet black.

Lay in permanent green light and lay wrinkled plastic food wrap on the wet color. Soften some areas with a damp brush. Then lay in a few strokes of black and white to create the veins. Soften parts of the veins.

Highlights are airbrushed in with a thin mixture of white cooled with cerulean blue. The shadows are airbrushed with a mixture of Payne's gray and raw umber watercolor.

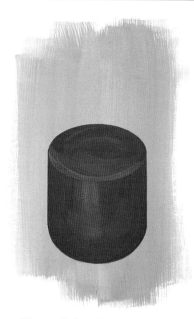

When painting glass, remember that highlights in the reflections are white and therefore must be painted against a background color other than white. Here I use green, and on that background I paint the contents of the glass.

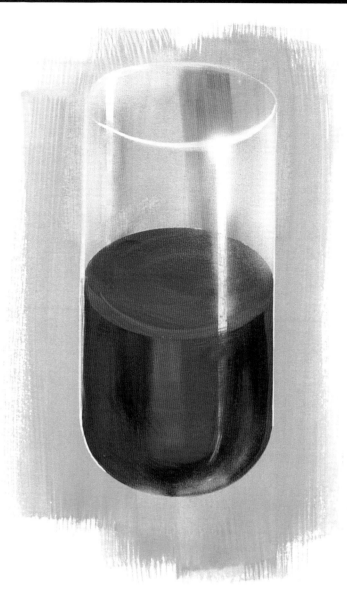

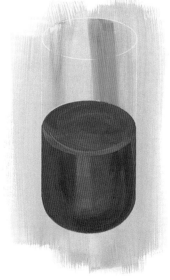

Knowing that my light source will come from the right/front, I apply the accents where they will create the greatest contrast with the highlights.

The highlights are applied with permanent white. The trick is to get by with as little as possible. Too many highlights and the glass will look opaque, not transparent. Pause after each stroke, and when it looks like glass, stop. Doing more will detract from the effect.

Congratulations are in order; you've gotten to the end of the color theory and recipes. You've learned how to handle gouache and paint everything from smooth transitional tones to craggy textures. You know what qualities to look for when choosing gouache. Now you know more about painting with gouache than 80 percent of all professional artists. The step-by-step demonstrations in the next chapter will narrow that margin down. By following along as you did in the previous chapters, you'll finish this book knowing even more. You'll soon be competing with the best of us.

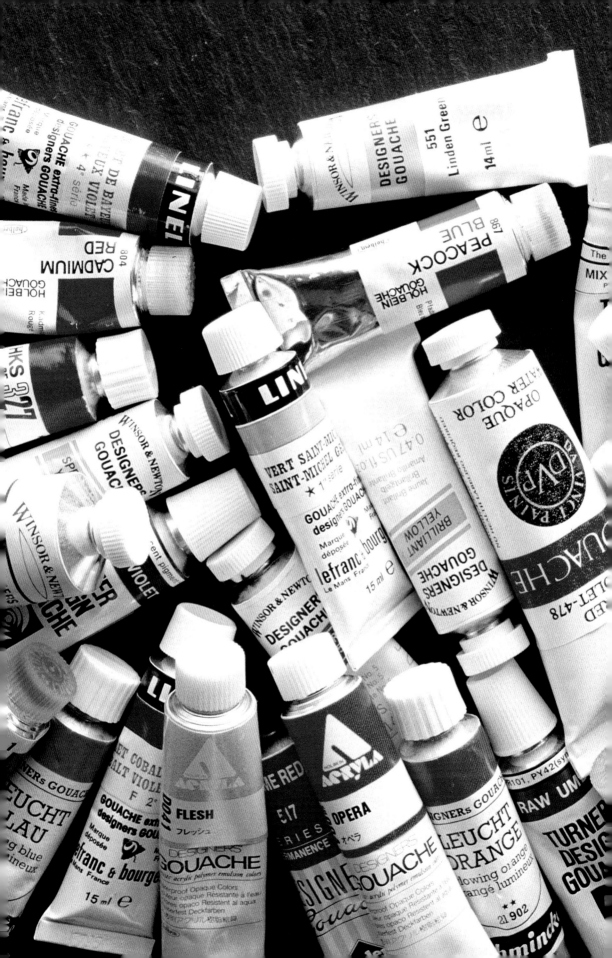

6 GOUACHE
DEMONSTRATIONS

BY THE TIME you reach this part of the book, you should be familiar with the basic characteristics of gouache—how it compares to other mediums and how it behaves. You have been given advice on choosing gouache, mixing it to the right consistency, and applying it to achieve different effects. By now you should be able to lay in flat and gradated tones and render lines and textures with brush, ruling pen, and airbrush. You have made your own gray card and know how use it to judge values. Using the Quiller Wheel, you can mix any color you need. You have experimented with the color recipes, and are ready to paint successful gouache illustrations.

The demonstrations in this chapter have been designed to teach a variety of techniques and show a variety of applications. We begin with a simple illustration built on flat, opaque areas and progress through demonstrations that become increasing complex. You'll find illustrations for advertising, scientific applications, and children's books, as well as works of art painted with gouache. You'll see how to apply many of the techniques you have already learned, as well as some special tricks you have not seen before.

DESIGN FOR A SILKSCREEN POSTER

Most of us have grown to think that gouache can be used only for flat, opaque areas of color, as demonstrated here. Hence the confusion between gouache and poster paint. But as we learned in Chapter 3, gouache is capable of being blended into subtle transitions. In this introductory demonstration, however, we will forgo any blending of tone and exploit the opacity of gouache.

I have selected a combination of six colors (combination #699) from *Designer's Guide to Color 3* (see Bibliography). The hunter green background is a mixture of Holbein Acryla Colored Gesso applied with a brush. At one point in the demonstration, I decide one of the colors is wrong, and the acrylic gesso allows me to wash off the gouache. The golden ochre border and the rest of the illustration are painted with Holbein Gouache. The support is an 11" (28-cm) square of #80 Bainbridge board, which has a cold-pressed finish, perfect for painting with gouache. After masking the border with Scotch 811 Removable tape, I seal the area to be painted with a light coat of Liquitex matte medium. This seals the edges and prevents any paint from creeping under the tape.

A mixture of Holbein Acryla Colored Gesso is used to make the hunter green background. Color combination #699 is shown peeking through the mass of jars. Liquitex matte medium is used to prevent paint from creeping under the masking tape.

The drawing is transferred with yellow Saral paper. I trace with a hard Verithin red pencil. The red line lets me know which lines have been traced and which lines remain to be traced.

The lettering and the circles are drawn with a ruling pen. The paint is floated up to the edges. This shade of magenta is not completely opaque, so it requires two coats.

The six colors (two greens, two magentas, and two ochres) are thinned to a proper working consistency and kept in airtight bottles.

The light shade of magenta is floated up to the inside of the circle. I apply it in a heavy coat, which causes a bit of streaking. Because this design is not meant to be color separated, streaking is of little consequence. To avoid streaking, apply two thin coats.

The light shade of green covers
easily with only one coat. At this
point I notice that I made a poor
choice in painting the stockings
in light magenta. Fortunately,
because I used an acrylic gesso, I
can wash off gouache and leave
the background color.

In order to show the effect of
painting gouache on a colored
support, I paint the same subject
on white. The colors appear to be
entirely different when painted on
white. The color of the support
strikes through any but the most
opaque coats of color. The white
support clearly demonstrates the
differences that exist between each
color. The tiny amount of green
striking through, has a unifying
effect on all the colors.

The finished artwork is now ready to be made into a silkscreen.

SIMPLE ILLUSTRATION STYLE FOR MULTIPLE APPLICATIONS

This is an easy-to-do illustration style that you can use for everything from advertising to book illustration. It's built on a simple outline drawing—just like those found in a coloring book. Except for the background, it is painted with Turner Designers Gouache using a Liquitex #3 and a Winsor & Newton Series 7 #2 brush. The background is painted with an airbrush using ComArt transparent airbrush color, which won't bleed through the overpainting. The support is a 9" x 11" (23 x 28 cm) piece of strippable Crescent 59208 Scanner Board. Because I have chosen gouache for this illustration, I am able to remove color that I decide is too strong. Ease of correction is just one of the many qualities that makes gouache a favorite medium of illustrators.

To keep the background from bleeding through the overpainting, I paint it with ComArt transparent airbrush color. This product is made with a water-resistant hydrocarbon resin. After cutting a frisket for the foreground figure, I spatter with ComArt sprayed at very low pressure (5 psi). To prevent slick spots that might resist the application of gouache, the entire surface is sprayed with Grumbacher Myston.

The highlights on the bas relief figure in the background are painted with a mixture of white and raw sienna. The shadows are painted with a wash of burnt sienna and indigo. At this point I wish I had done the spatter with gouache. Gouache would not strike through the overpainting as much as the dots of ComArt do. I paint the headband with an underpainting of violet rose.

The mass tone of the flesh areas is painted with a bit of white mixed into jaune brilliant. I know that I'll be laying a lot of thin glazes of color on top of this mass tone, so I opt to use Turner Acryl Gouache. The Acryl Gouache won't pick up when I lay a wet glaze on it.

The hair is massed in with a flat tone of jet black. Light blue and brilliant violet are mixed together and painted into the headband, leaving some of the underpainting showing. Glazes of yellow ochre, Venetian red, and cadmium scarlet are blocked into all the fleshtones.

Sky blue is washed over the tunic. When the wash dries, I paint a heavier layer of sky blue to define the folds of the fabric. I mix a little gray with the sky blue and paint the shadows in the sleeve and the belt.

Now it's time to paint the vanes of the arrow and the belt. For them I choose cadmium scarlet and permanent yellow orange. Does this color combination look familiar? It should. It's been used several times in this book. Using a slightly dampened brush, I blend the glazes in my fleshtones.

With a little light blue on my brush, I cut a bit of simple decoration into the headband. The shaft of the arrow and staves of the bow are painted in earth tones. I had laid in a rather heavy indigo into the body of the bow. It was all wrong. I washed it away, leaving just a stain and a small amount of pure color around the hand. Only gouache allows you to change your mind that easily.

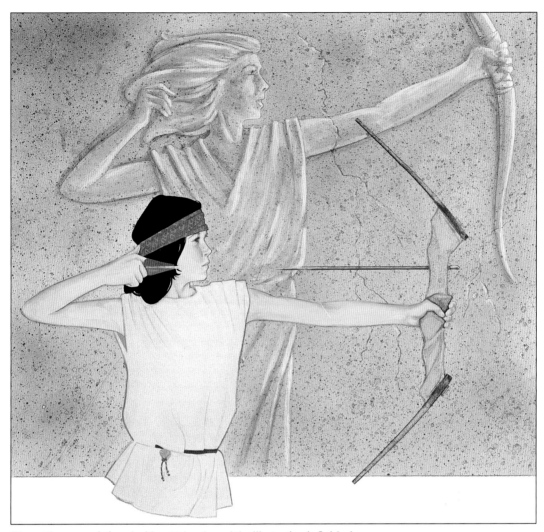

The outlines are reinforced with a #2 brush, and the illustration is finished.

CHILDREN'S BOOK ILLUSTRATION

When I was a young illustrator, one of the first large assignments I received was a series of 120 illustrations for a children's textbook. In it I employed two styles: a realistic one to illustrate factual material and a decorative style to illustrate the fictional. This illustration about a boy's daydream of a horse is a loose translation of an illustration done more than twenty-five years ago.

The decorative approach employed here is a transition between the flat poster style shown in the first demonstration and the more highly rendered examples demonstrated later. I find it difficult to use this much bright color and texture and keep the picture from turning into a jumble. But it is an effect that every illustrator needs to master.

The demonstration is done with Holbein Acryla Gouache and Holbein Designers Gouache on an 11"x 15" (28 x 38 cm) piece of #80 Bainbridge cold-pressed illustration board. A Winsor & Newton #2 Series 7 brush is used, along with a Liquitex #3. Holbein's Hira-Fude and KHX flat brushes are used to blend the passages.

Rather than masking out the foreground figures, I prefer to paint them on top of the graded background, using the background as an imprimatura. To prevent the background colors from striking through the overpainting, I use Holbein Acryla Gouache, applying it with an Iwata HP-C airbrush. A circle of acetate is held slightly away from the surface with a small wad of rolled-up tape. This allows me to get a soft-edged penumbra around the center of the star.

Because I intend to do extensive painting on top of the body of the horse, I paint it with jet black Acryla Gouache. To be water-resistant, this paint requires at least a 15-minute drying period. While waiting I thoroughly clean my airbrush and wash my brushes with soap and water.

At this point I switch to Holbein's traditional Designers Gouache. I paint in the underlit sections with a mixture of jaune brilliant #2 and gray #3. A transitional tone is made by darkening that mixture with ivory black. The toplit sections are painted with a mixture of cerulean blue and gray #3. As in the underlit section, a transitional tone is made using the color mixture and ivory black.

Accents are added with jet black, a color that is much blacker than ivory black. The tones are blended with a slightly dampened brush that I wash off after each stroke to prevent contaminating the colors with jet black. The horse is taking on a bas relief quality, reminiscent of an art deco monument.

If I can, I usually prefer to work from the background toward the foreground. However, strong colors and contrasts must be applied at the outset. The chroma strength of this violet is far too powerful and dominant to be put in at the last moment. In this application, it is a pivotal color requiring the other colors to be mixed to harmonize with it.

To keep the viewer's eye moving, I add an area of interest to move it away from the color and texture of the saddle blankets and tack. I apply cadmium yellow orange to the hair, a color that really stands out against the blue background (its visual complement). The tunic is a neutral "rest area" between the bright colors. It is painted with a warm gray mixed from gray #2 and raw umber.

Turquoise is neutralized with gray #1. Notice how many colors I've neutralized in order to make a few colors appear to glow. Some of the colors are neutralized with gray; others, with their complement. Darker tones are mixed and painted in as shadows. The shadows are handled like typographic "drop shadows" to create the shallow depth we associate with a bas relief.

This closeup shows a puddle of Chinese orange that has been floated into the bridle. It will dry to be a perfectly flat area.

All of the areas have been blocked in. The colors are a bit spotty and fight with one another. But by carefully choosing the colors used in the decorations, I make the colors harmonize. I glaze shadows with Grumbacher raw umber watercolor applied with an airbrush.

Except for the lime green eye, the "ghost horse" is a simple monochrome painted a bit warmer on the bottom than on the top. The star is airbrushed with Luma Pro White. Acetate masks are used.

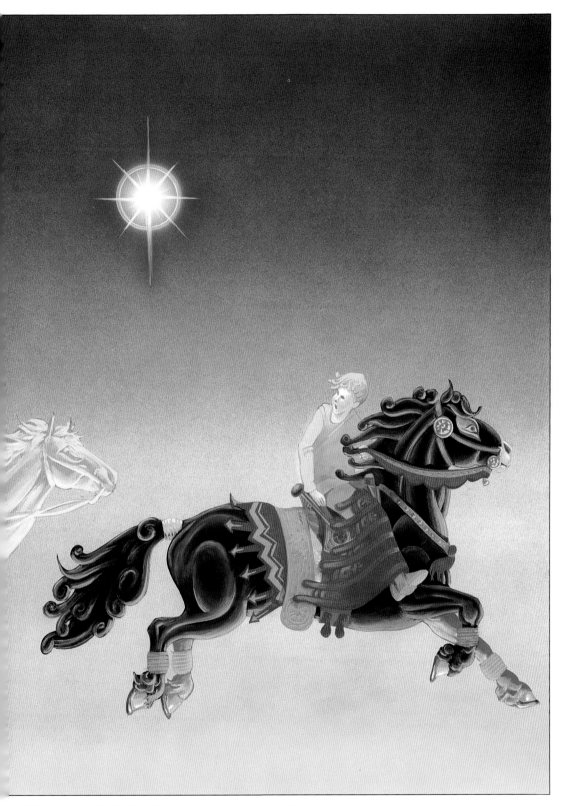

The piece is finished after a few areas are sharpened up with a brush or a colored pencil.

SCIENTIFIC ILLUSTRATION

In my youth I had cows kick me, butt me, knock me down, and step on me. Now the tables are turned, and it's my turn to dissect one—artistically, that is. Gouache is ideal for scientific illustration because it allows for precise edges and easy correction. The drawing is done on a piece of #80 Bainbridge illustration board, which has a cold-pressed finish. Because anatomy drawings are complex, the lines are gone over with a metal stylus so that the drawing can be found under coats of opaque paint.

The entire painting is done with Schmincke HKS Design Gouache using Liquitex #3 and #2 and Holbein Hira-Fude brushes. To reduce the risk of creating slick spots that might repel paint, I take the precaution of spraying the board with ox gall and allowing it to dry before applying any paint. This also raises the texture of the surface.

A wash of raw sienna and mixing white is applied along with some pink in the nose, followed by sienna and ivory black in the horns and the hooves. Staring malevolently from behind the tubes of paint is my photo reference.

An opaque wash of English red and pink Madder lake light is massed into the musculature. Although some of the pencil lines are obscured, the indented lines are still apparent.

Working from the back to the front, I paint the dark areas of the back and paunch with a mixture of Prussian blue and raw umber. The highlights are then softened with light blue. The white areas are painted by scumbling an opaque titanium white into which I've mixed a hint of ultramarine purple. The resulting chalky, pale lavender color is set off by the clear, warm undertone, which has been allowed to dominate at the bottom of the paunch. The cow's baleful glance is added.

The musculature is outlined with crimson lake lightened with a bit of mixing white. Shadows are drybrushed in the direction of the tissue growth with the same crimson mixture. A few touches are added to the nose and eye.

Viridian is added to the crimson mixture, both to darken and to neutralize it. In order to avoid the repellent look of a slab of meat, I've applied only cool colors over the warm pink underpainting.

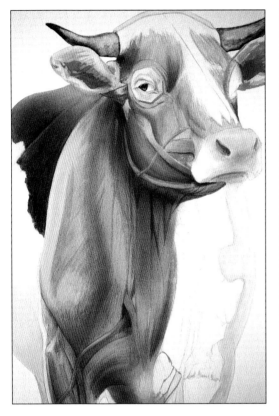

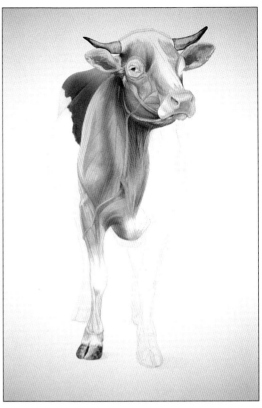

This detail is photographed in raking light to show how drybrush takes advantage of the slight tooth of #80 Bainbridge board. In this light, the indented lines are more apparent.

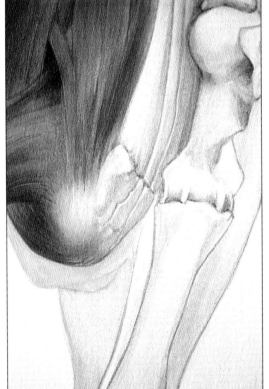

The musculature and the nose are finished. Now it's time to work on the skeleton.

The raking light in this detail creates the illusion of transparent washes. The extensive use of drybrush adds to that illusion. Actually, the paint is quite opaque. Notice the interplay of warm and cool colors used for rendering the skeleton.

The finished piece is an example of handling a complex subject in a quick and efficient manner.

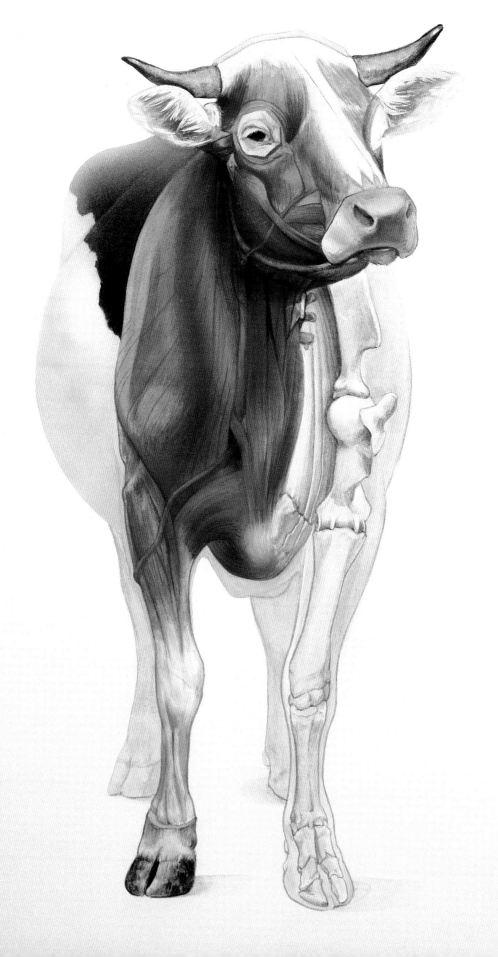

AUTOMOTIVE ILLUSTRATION FOR ADVERTISING

Certainly one of the most demanding fields in illustration is automotive. More difficult still are X-ray views, also known as fadeaways. One of this country's top automotive illustrators, John Ball of Detroit's Skidmore-Sahratian illustration studio, is an acknowledged master of this difficult genre. In this illustration, which is not as daunting as some of his more complex X-ray views, he reveals previously unpublished studio secrets.

Ball keeps his equipment simple—almost to the point of being sparse. He uses #110 Crescent cold-pressed illustration board. Winsor & Newton Designers Gouache is spread out on an enamel meat tray. The colors are applied with Liquitex #2, #3, and #4 Kolinsky sable brushes.

Some Notes on John Ball's Technique

Ball mixes a large puddle of color to match a paint chip that is a piece of thin metal sprayed with the actual automotive paint. This is his mid-value mass tone. At times he stores this mass tone in a baby food jar or test tube in order to keep it moist and usable. When painting reflective surfaces like sheet metal, he defines the tonal areas by the effect of three major influences:

1. Sunlight—lighten the mass tone with white. Ball finds that pure white highlights, used alone, reduce the chroma strength of the adjacent colors, making the highlights look bleached out.

2. Sky reflection—gradually lighten the mass tone with a light blue "sky color."

3. Horizon—just as the sky color is reflected into the highlights, the ground color is reflected into the shadows. Ball never adds black to shadows; he feels it makes them muddy. Instead, he mixes the mass tone with deeper values of itself and with its visual complement (in this case, violet).

The preliminary drawing is generated on Skidmore-Sahratian's graphics-dedicated computer. As Ball explains, this is a new technique. Traditionally, the drawings were made from product photos supplied by the advertising agency or from reference photos taken by the studio photographer. Often the studio shoots last year's model in the correct view and Ball updates the changes, working from styling photos and blueprints.

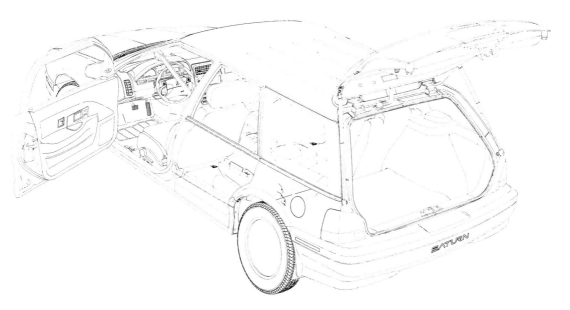

The drawing is 26″(66 cm) wide as it comes from the computer. While you and I might find it impressive, the drawing is not to Ball's liking. He has it photostatted down to 18″ (48 cm), tapes it to the board, and corrects the computer art as he traces it (he moves the driver's door, alters the tailgate, fixes the trim inside the tailgate opening, and smoothes the curves). The drawing is transferred by tracing through the photostat and a graphite transfer sheet with the aid of a metal stylus.

Here is the drawing traced in graphite. Before applying the all-over wash of color, Ball uses his metal stylus to groove in any important lines that will be covered with opaque paint (door lines, hood lines, louvers, wind splits, and such). Because of gouache's matte surface, there is no danger of the indented lines being picked up by the camera. The darkest darks (the tires) are established at this time.

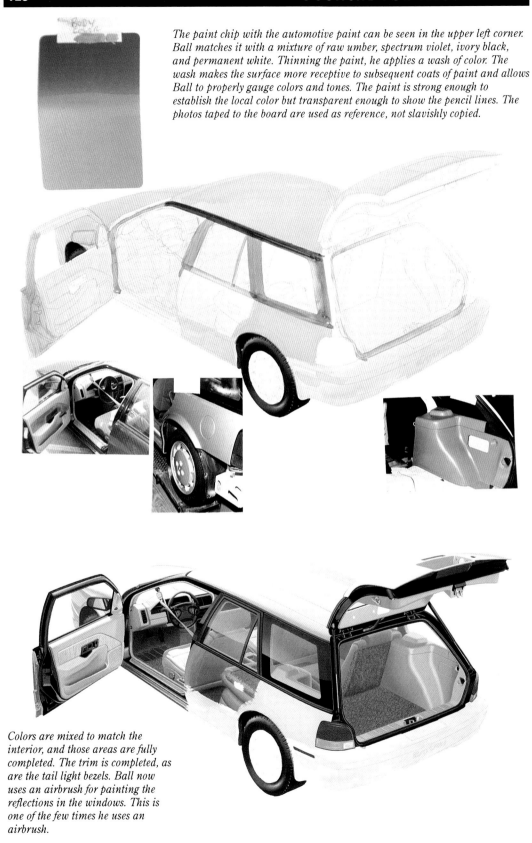

The paint chip with the automotive paint can be seen in the upper left corner. Ball matches it with a mixture of raw umber, spectrum violet, ivory black, and permanent white. Thinning the paint, he applies a wash of color. The wash makes the surface more receptive to subsequent coats of paint and allows Ball to properly gauge colors and tones. The paint is strong enough to establish the local color but transparent enough to show the pencil lines. The photos taped to the board are used as reference, not slavishly copied.

Colors are mixed to match the interior, and those areas are fully completed. The trim is completed, as are the tail light bezels. Ball now uses an airbrush for painting the reflections in the windows. This is one of the few times he uses an airbrush.

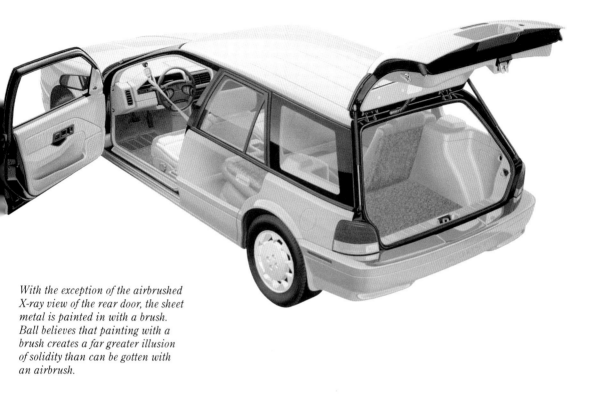

With the exception of the airbrushed X-ray view of the rear door, the sheet metal is painted in with a brush. Ball believes that painting with a brush creates a far greater illusion of solidity than can be gotten with an airbrush.

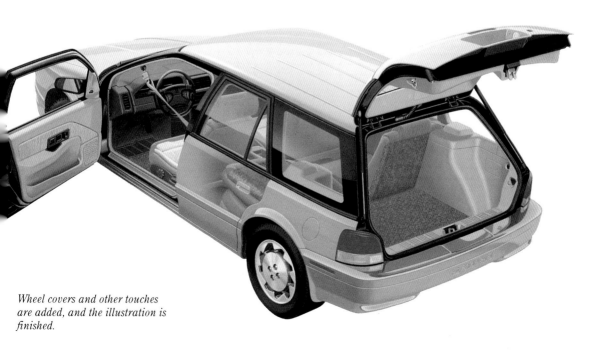

Wheel covers and other touches are added, and the illustration is finished.

LANDSCAPE PAINTING

lthough I can't claim Monet's talent for landscape painting, I share his passion for gardening. When designing a garden scene, balancing plants in the shade with plants in full light is a subtle and demanding art, but one that is critical to a successful outcome. This view from the shade beneath a mammoth copper beech shows a dense undergrowth of hosta being guarded by a statue of a smiling pig. In the light, you can make out foxgloves, delphiniums, and hollyhocks as they spire upward from masses of peonies. A wisteria, trained as a tree, and two vine-covered columns frame the sun-drenched garden, and arborvitae and maples languish in the background.

For this painting I use Holbein Acryla Gouache and Holbein Gouache on a 15" x 20" (38 x 50 cm) piece of #80 Bainbridge board. Acryla gouache is used for the underpainting, so that subsequent layers of gouache can be applied without the risk of disturbing the underpainting.

Over a red chalk drawing I lay a thin wash of burnt umber. I apply the wash with a coarse bristle brush in order to create a streaky ground. Subsequent washes of color will sparkle when painted over the streaky ground.

Using thin washes and working quickly, I lay in the shadows with purple. The brightest purple is used in the shaded areas under the trees. As objects recede into the distance, the purple shadows are made less intense through the addition of gray. Attention is paid to playing the cool, lush greens off against warm greens.

It is here that gouache comes into its own, especially Acryla gouache. Areas where light comes through the tree branches are painted in concentric circles of warm color—I'm painting the penumbra that surrounds every light source. The same outlined shapes are echoed in the background with subtle variations of grays and greens.

The colors of the lightstruck flowers are added, along with numerous details. The granite statue is painted in raw umber and gray. Although there are transparent as well as opaque areas, they form a cohesive whole that would not have been possible if opaque color had been added to a transparent watercolor painting. A subtle layer of mauve is scumbled into the shadow at the top. For this the airbrush is the perfect tool.

FANTASY
ILLUSTRATION

During the early 1970s, I was kept busy painting cover illustrations for publishers of science fiction. I developed a slick, facile style that was perfectly suited to the shiny machines of the future. When I decided to do a demonstration of this kind of illustration for this book, I had no misgivings; after all, I had done it dozens of times before. I was confident that once I started, it would come back to me, sort of like riding a bicycle. Boy, was I wrong! It was more like trying to remember how to ride a unicycle. In the past two decades my approach to painting has freed up and become looser. Clearly, in order to paint this demonstration, I would have to learn the technique all over again.

The illustration is painted with Holbein Gouache and Schmincke HKS Design Gouache on a 10" x 15" (25 x 38 cm) #80 Bainbridge board. This size board allows me to see the entire scene as I work, whereas a larger board would not. I use Liquitex #3 and Winsor & Newton #2 Series 7 brushes and a Holbein Hira-Fude flat, as well as an Iwata HP-C airbrush.

The drawing is carefully applied with a hard 4H pencil. I press hard enough to cause the lines to indent into the surface of the board. The shuttle craft is frisketed with Badger Foto Frisket Film and the background is laid in with a 3" (7.5 cm) brush. The canyon is painted with a bright yellow-orange with purple shadows. The interplay of hard edges against soft edges creates a feeling of depth. A neutralized orange color is used to paint in the craggy surface of the rocks.

A damp brush is stroked into the background colors, softening them and creating the effect of heated gases coming from the rear of the shuttle craft. The background is completed and the frisket removed.

The lines of the drawing are redrawn with a stylus and indented into the surface of the illustration board. The stylus shown is nothing more than a crochet needle that has been ground and polished. Because of gouache's nonreflective matte surface, the indented lines will not be readily apparent.

A loose mask of tracing paper protects the surrounding area. The reflective parts of the shuttle craft are painted with brush and airbrush. In order to create the feeling of a craggy landscape reflected in the shiny surface, I've made a maskout of ripped paper. The final effects of such a mask are shown in the bronzed glass canopy This slick effect is very easy to achieve.

With the exception of a bit of smoothing, this section is finished. The reflected sunset is laid in with a brush. Later it will be smoothed with a damp brush. The straight lines are drawn with a brush guided along a ruler.

Just when things are going well, I switch brands of paint. Beguiled by the lovely proprietary colors of LeFranc & Bourgeois, I try to paint the nose with yellow- gray and mouse gray. It's a disaster. The paint dries streaky, the surface is shiny, and the strokes won't lie smooth on the surface. Unfortunately, the surface of the support is disturbed when it is removed. I go back to using Holbein and Schmincke gouache.

The body color is laid in with a warm gray made of Holbein gray #2 mixed with permanent yellow. This step has been photographed in a raking light so that the indented lines can be seen. As detail is added, the lines will all but disappear.

Painting the details requires no more than basic rendering techniques. A mixture of light blue is used as a sky color and will be mixed with the mass tones to create highlights. A deep orange is mixed with the mass tones to create the shadows. Any areas to be airbrushed must be masked with acetate because frisket film might pick up some of the paint. If you look very closely, you can see the slightly rough surface left from removing the paint on the nose.

STILL LIFE PAINTING

Daniel K. Tennant demonstrates the versatility of gouache as a medium for the fine artist. Gouache is particularly suited to a sharp-focus style like Tennant's because it allows for precise edges and airbrush effects. Known for his convincing still life paintings of silver objects, Tennant takes us through one from start to finish, making it look easy.

After the resolving the composition, he transfers the drawing to a 30" x 40" (76 x 102 cm) piece of hot-pressed illustration board (#172 Bainbridge). The smooth board allows him to create his own textures and details rather than imposing a texture as a cold-pressed or rough-surfaced support does. It's interesting to note that Tennant prefers synthetic brushes to sable, and for this demonstration he uses Winsor & Newton's Sceptre brushes. The paint is Winsor & Newton Designers Gouache, with occasional glazes of W&N watercolor.

The satin pillow is massed in with Naples yellow, Chinese white, and alizarin crimson. The folds and highlights are laid in with an Iwata HP-C airbrush. Later the oversprayed areas in the teapot will be covered with opaque paint. Wrinkles are painted with a long-haired rigger brush or scratched out with an X-acto knife. The edges of the pillow are then masked off before the black in the Persian rug is painted.

The patterns in the Persian rug are painted with light cobalt blue, dusty pinks, and browns, along with several off-whites. The color areas are outlined with black before the shadows are added. A thin mixture of ivory black and ultramarine blue watercolor is airbrushed to create transparent and luminous shadows. Using a thin mixture of ivory black and ultramarine gouache, Tennant creates a convincing texture by crosshatching over the entire rug. As a reference point, he adds a small red reflection to the teapot.

The texture of the oak drawers is airbrushed with yellow ochre, burnt sienna, and burnt umber. Tennant uses the airbrush to delineate the grain of the wood as well as the cast shadows.

A dark mixture of burnt umber, cobalt blue, and Naples yellow is used as an underpainting for the fringe. It is much darker than the actual fringe and will help give the illusion of shadow underneath. Tennant considers this one of the big advantages of painting with gouache—the ease of working from dark to light.

The mass tone of the strawberries is quickly established, along with their reflections in the sugar bowl. The yellow apple in the background is completed, and the teapot's spout is laid in with a coat of ivory black. Here Tennant begins rendering the top of the teapot. The little knob is finished, but the rest of the top reveals a great deal about one of Tennant's approaches to painting reflective surfaces. Unlike the spout, the top is painted from light to dark. Its handling is unlike that for the rest of the teapot.

Over the black underpainting on the spout, Tennant starts his reflections with a dark lavender and deep yellow ochre, gradually raising the mixtures with white as the painting progresses. The yellow reflection of the apple can be seen on the bottom curve of the spout. The soft, halated highlights are done with the airbrush.

The body of the teapot was underpainted in black and painted with the same tones and shades of lavender. By faithfully recording the fruits, flowers, and other objects in the reflections in the silver, Tennant creates a very persuasive and painterly rendering, avoiding a static photographic appearance. The delicate hatching and scraping in the main highlight are the crowning effect.

The apples are blocked into the foreground; they will be finished later. Notice how the overspray from the apple on the left has been allowed to creep into the side of the creamer. This is not a mistake. It provides an underpainting for Tennant to follow. Working from the background to the foreground eliminates the need to paint the edges of objects more than once. Details are drawn into the black top of the sugar bowl. Tennant recommends doing this with a white charcoal pencil because it will be absorbed into the paint. Conté pencils will smear when painted over.

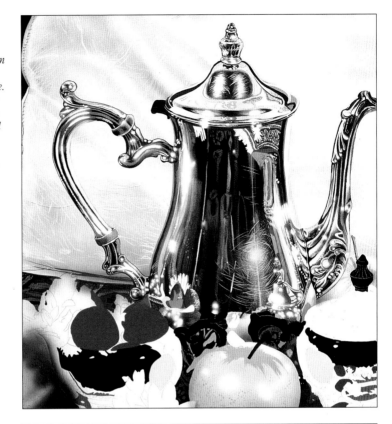

This detail shows the complexity of the reflections. Notice how Tennant has given each reflected highlight its own character. No two are alike. This adds interest to the picture.

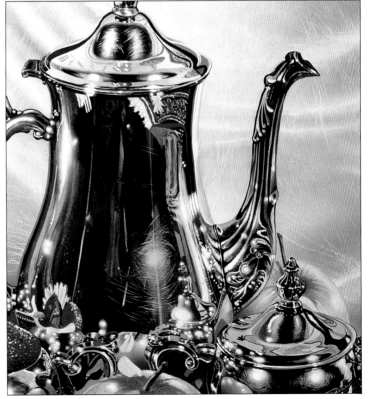

Overspray from the apple has been incorporated into the reflection. The reflected highlight on the right has been given a starburst effect, adding to the viewer's interest.

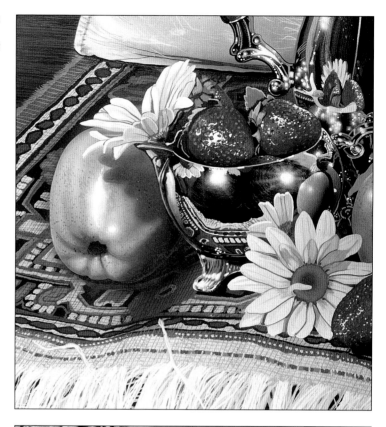

This detail shows, in the fringe, the extraordinary covering power of gouache. Just one stroke of properly mixed gouache will cover even the darkest shadow. Every object appears to have the proper weight—the flowers are lighter than the strawberries, and the sugar bowl sits solidly on the rug. It makes you wonder whether it is full of sugar.

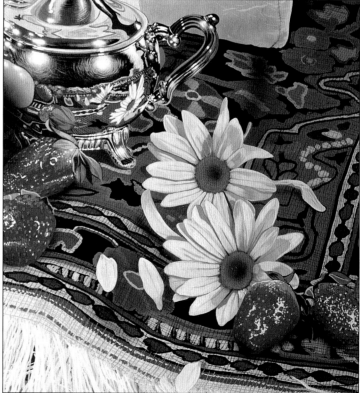

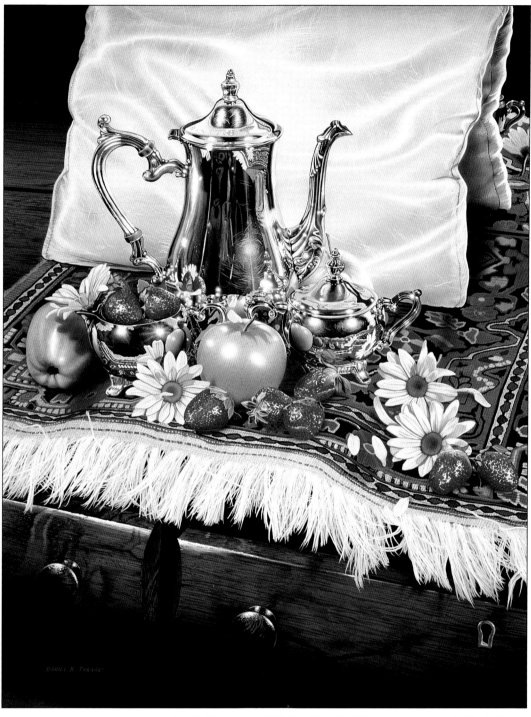

The finished piece, Still Life with Satin Pillow, *is signed in red at the bottom. Tennant varnishes this painting with Kamar varnish, although he usually leaves a painting unvarnished and displays it behind UV Plexiglas. Varnishing, if carefully done, causes very little shifting of color and tone. However, it does alter the matte surface of the painting.*

BIBLIOGRAPHY

Albers, Joseph. *Interaction of Color.* Rev. ed. New Haven: Yale University Press, 1975.

Allen, Douglas, and Douglas Allen, Jr. *N. C. Wyeth.* New York: Bonanza, 1972.

Berger, John. "Problems of Socialist Art," *Labour Weekly* (London), March 1961 and April 1961.

Birren, Faber. *Creative Color.* New York: Van Nostrand Reinhold, 1961.

———. *New Horizons in Color.* New York: Reinhold Publishing Corp., 1955.

Broder, Patricia Janis. *Dean Cornwell.* New York: Balance House, 1978.

Chevreul, M. E. *Principles of Harmony and Contrast of Colours.* London: Bell & Daldy, 1870.

De Reyna, Rudy. *Painting in Opaque Watercolor.* New York: Watson-Guptill, 1969.

Doerner, Max. *The Materials of the Artist & Their Use in Painting.* Rev. ed. New York: Harcourt, Brace and Co., 1949.

Dunn, Harvey. "An Evening in the Classroom." Notes taken by Miss Taylor and printed at the instigation of Mario Cooper (no further attribution).

Eastlake, Sir Charles Lock. *Materials for a History of Oil Painting.* London: Longmans, Green and Co., 1869.

Ellenberger, Baum, and Dittrich Ellenberger. *An Atlas of Animal Anatomy for Artists.* Rev. ed. New York: Dover Publications, 1956.

Evans, Ralph M. *The Perception of Color.* New York: John Wiley & Sons, 1974.

Fawcett, Robert. *On the Art of Drawing.* New York: Watson-Guptill, 1958.

Friedlander, Max J. *From Van Eyck to Breughel.* London: Phaidon, 1956.

Grosz, George. *A Little Yes and a Big No.* New York: Dial, 1946.

Henri, Robert. *The Art Spirit.* Philadelphia: J. B. Lippincott Co., 1960.

Howard, Rob. *The Illustrators Bible.* New York: Watson-Guptill, 1992.

Hunt, William Morris. *On Painting and Drawing.* New York: Dover, 1976.

Itten, Johannes. *The Art of Color.* New York: Van Nostrand Reinhold Co., 1973.

———. *The Elements of Color.* New York: Van Nostrand Reinhold Co., 1970.

Jacobson, Nathaniel. *The Sense of Color—A Portfolio of Visuals.* New York: Van Nostrand Reinhold Co., 1975.

Jung, Carl G. *Man and His Symbols.* London: Aldus Books, 1964.

Klee, Paul. *Padagogisches Skizzenbuch [Pedagogical Sketchbook]. Bauhausbuch No. 2.* Trans. by Sibyl Moholy-Nagy. New York: Praeger, 1953.

Lehmann-Haupt, Helmut. *Art Under a Dictatorship.* New York: Oxford University Press, 1954.

Loomis, Andrew. *Creative Illustration.* New York: Viking Press, 1947.

———. *The Eye of the Painter.* New York: Viking Press, 1961.

Luckiesh, M. *Color and Its Applications.* New York: D. Van Nostrand & Co., 1921.

Manifeste du Surrealisme: Poisson soluble. Paris: Simon Kra, 1924.

Manifestes du Surrealisme [The Collected Manifestoes]. Paris: Pauvert, 1962.

Mayer, Ralph. *The Artist's Handbook of Materials and Techniques.* 3d rev. ed. New York: Viking, 1970.

Munsell, Albert H. *A Color Notation.* Baltimore: Munsell Color Co., 1936.

———. *A Grammar of Color.* Mitteneague, Mass.: The Strathmore Paper Company, 1921.

Ostwald, Wilhelm. *Colour Science, Parts I and II.* London: Winsor & Newton, 1933.

Quiller, Stephen. *Color Choices.* New York: Watson-Guptill, 1989.

Read, Sir Herbert. *The Politics of the Unpolitical.* London: Routledge, 1946.

Richer, Paul. *Nouvelle Anatomie Artistique du Corps Humaine.* Paris: Plon-Nourrit et Cie., 1920.

Richter, Hans. *Dada; Art and Anti-Art.* New York: McGraw Hill, 1965.

Rockwell, Norman. *Rockwell on Rockwell.* New York: Watson-Guptill in cooperation with Famous Artists School, 1979.

Rood, Ogden. *Text-Book of Color.* New York: Appleton, 1881.

Ross, Denman. *The Painter's Palette.* Boston: Houghton Mifflin, 1919.

Sepeshy, Zoltan. *Tempera Painting.* New York: American Studio Books, 1946.

Severini, Gino. *Arte Independente, arte borghese, arte sociale.* Rome: Danesi, 1944.

Shibukawa, Ikuyoshi, and Yumi Takahashi. *Designer's Guide to Color 2 and 3.* San Francisco: Chronicle Books, 1984.

Tennant, Daniel, "Still Life, Silver and Success," *American Artist,* October 1992.

Van Wyk, Helen. *Successful Color Mixtures.* Rockport, Mass.: Art Instruction Assocs., 1979.

Woody, Russell O., Jr. *Painting With Synthetic Media.* New York: Reinhold, 1965.

Woolery, Lee. *Marker Techniques: Rendering Reflective Surfaces.* Cincinnati: North Light Books, 1988.

Wolfe, Tom. *From Bauhaus to Our House.* New York: Farrar, Straus & Giroux, 1981.

INDEX